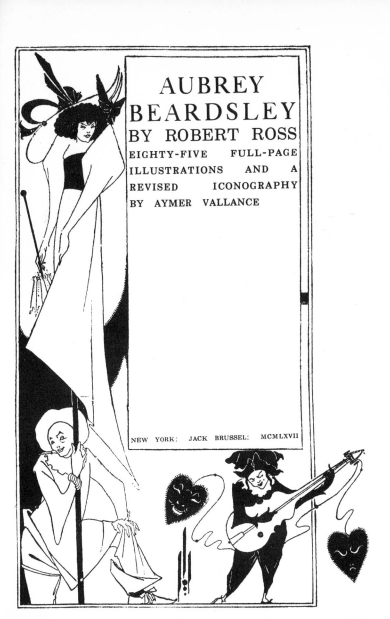

AUBREY BEARDSLEY

BY ROBERT ROSS

EIGHTY-FIVE FULL-PAGE
ILLUSTRATIONS AND A
REVISED ICONOGRAPHY
BY AYMER VALLANCE

NEW YORK: JACK BRUSSEL: MCMLXVII

Printed in the U.S.A.

AUBRFY BEARDSLEY

SAVOY: Self Portrait.

AUBREY BEARDSLEY

AUBREY BEARDSLEY was born on August 21st, 1872, at Brighton. He was a quiet, reserved child, caring little for lessons, though from an early age he shewed an aptitude for drawing. He began his education at a Kindergarten. He was seven years old when the first symptoms of delicacy appeared, and he was sent to a preparatory school at Hurstpierpoint, where he was remarkable for his courage and extreme reserve. Threatened with tuberculosis, he was moved for his health to Epsom in 1881. In March 1883 his family settled in London, and Beardsley made his first public appearance as an infant musical phenomenon, playing at concerts in company with his sister. He had a great knowledge of music, and always spoke dogmatically on a subject, the only one he used to say, of which he knew anything. He became attracted at this time by Miss Kate Greenaway's picture

books, and started illuminating menus and invitation cards with coloured chalks, making by this means quite considerable sums for a child.

In August 1884 he and his sister were sent back to Brighton, where they resided with an old aunt. Their lives were lonely, and Beardsley developed a taste for reading of a rather serious kind—the histories of Freeman and Greene being his favourite works. He could not remain a student without creating, so he started a history of the Armada! In November of the same year he was sent to the Brighton Grammar School as a day boy, becoming a boarder in January 1885. He was a great favourite with Mr King, the housemaster, who encouraged his tastes for reading and drawing by giving him the use of a sitting-room and the run of a library. This was one of the first pieces of luck that attended Beardsley throughout life. The head-master, Mr Marshall, I am told, would hold him up as an example to the other boys, on account of his industry. His caricatures of the masters were fully appreciated by them, a rare occurrence in the lives of artists. He cultivated besides a talent for acting, and would often

TO

SIR COLERIDGE ARTHUR FITZROY KENNARD,
BART.

perform before large audiences at the Pavilion. He organized weekly performances at the school, designing and illustrating the programmes. He even wrote a farce called "A Brown Study," which was played at Brighton, where it received serious attention from the dramatic critics of the town. He would purchase each volume of the Mermaid series of Elizabethan dramatists then being issued, and with his sister gave performances during the holidays. From the record of the "Brighton College Magazine," Beardsley appears to have taken a leading rôle in all histrionic fêtes, and to "The Pied Piper of Hamelin" he contributed some delightful and racy little sketches, the first of his drawings, I believe, that were ever reproduced.

In July 1888 he left school, and almost immediately entered an architect's office in London. In 1889 he obtained a post in the Guardian Life and Fire Insurance. During the autumn of that year the fatal hæmorrhages commenced; for two years he gave up his amateur theatricals and did little in the way of drawing. In 1891, however, he recuperated; a belief in his own powers revived. He now

commenced a whole series of illustrations to various plays, such as Marlowe's "Tamerlane," Congreve's "Way of the World," and various French works which he was able to enjoy in the original. He would often speak of the encouragement and kindness he received at this period from the Rev. Alfred Gurney, who had known his family at Brighton, and who was perhaps the earliest of his friends to realize that Beardsley possessed something more than mere cleverness or precocity.

Several people have claimed to discover Aubrey Beardsley, but I think it truer to say that he revealed himself, when proper acknowledgment has been made to Mr Aymer Vallance, Mr Joseph Pennell, Mr Frederick Evans, Mr J. M. Dent, and Mr John Lane, with whom Beardsley's art will always be associated in connection with the Yellow Book, that too early daffodil that came before the swallow dared and could not take the winds of March for beauty. To Mr Pennell belongs the credit of introducing Beardsley's art to the public; and to Mr Dent is due the rare distinction of giving him practical encouragement, by commissioning the illustrations to the "Morte d'Arthur," long before

SALOME: Suppressed Title Page.

SALOME: Title Page Published.

critics had written anything about him, or any but a few friends knew of his great powers. Beardsley was too remarkable a personality to remain in obscurity. Though I remember with some amusement how the editor of a well-known weekly mocked at a prophecy that the artist was a coming man who would very shortly excite discussion if not admiration. Fortunately Mr Pennell, a distinguished artist himself, and a fearless critic, not only espoused the cause of the new draughtsman, but became a personal friend for whom Beardsley always evinced great affection, and to whom he dedicated his " Album of Fifty Drawings."

I shall never forget my first meeting with Aubrey Beardsley, on February 14th, 1892, at the rooms of Mr Vallance, the well-known disciple and biographer of William Morris. Though prepared for an extraordinary personality, I never expected the youthful apparition which glided into the room. He was shy, nervous, and self-conscious, without any of the intellectual assurance and ease so characteristic of him eighteen months later when his success was unquestioned. He brought a portfolio of his marvellous drawings, in themselves an

earnest of genius; but I hardly paid any attention
to them at first, so overshadowed were they by
the strange and fascinating originality of their
author. In two hours it was not hard to dis-
cover that Beardsley's appearance did not belie
him. He was an intellectual Marcellus suddenly
matured. His rather long brown hair, instead
of being "ébouriffé," as the ordinary genius
is expected to wear it, was brushed smoothly
and flatly on his head and over part of his
immensely high and narrow brow. His face
even then was terribly drawn and emaciated.
Except in his manner, I do not think his
general appearance altered very much in spite
of the ill-health and suffering, borne with such
unparalleled resignation and fortitude: he al-
ways had a most delightful and engaging smile
both for friends and strangers. He grew less
shy after half an hour, becoming gayer and
more talkative. He was full of Molière and
"Manon Lescaut" at the time; he seemed
disappointed that none of us was musical; but
he astonished by his knowledge of Balzac an
authority on the subject who was also present.
He spoke much of the National Gallery and
the British Museum, both of which he knew

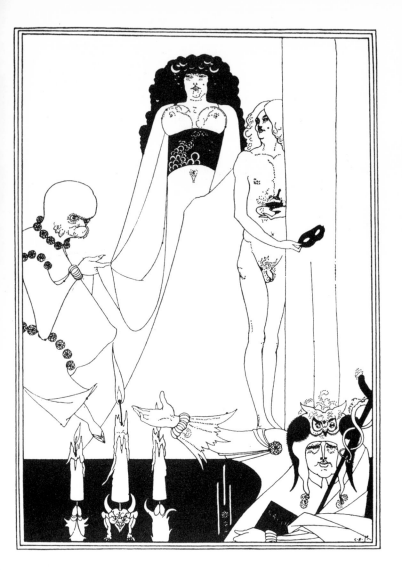

SALOME: Original of Enter Herodias.

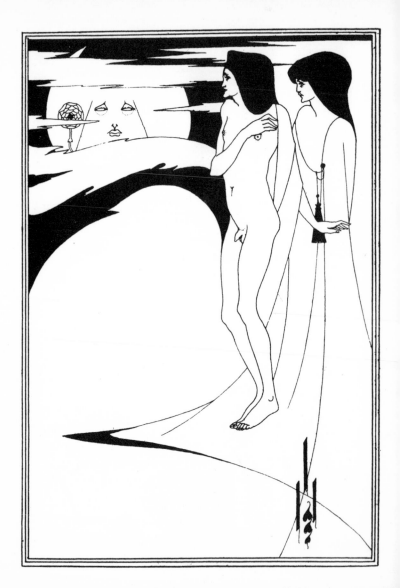

SALOME: The Woman in the Moon.

with extraordinary thoroughness. He told me he had only been once to the New Gallery, where he saw some pictures by Burne-Jones, but had never been to the Royal Academy. As far as I know, he never visited the spring shows of Burlington House. He always, however, defended that institution with enthusiasm, saying he would rather be an Academician than an artist, "as it takes only one man to make an artist, but forty to make an Academician."

Our next meeting was a few weeks later, when he brought me a replica of his "*Joan of Arc*." I was anxious to buy the first and better version, now in the possession of Mr Frederick Evans, but he refused to part with it at the time. He seemed particularly proud of the drawing; it was the only work of this period he would allow to have any merit.

In the early summer of 1892 he visited Burne-Jones and Watts, receiving from the former artist cordial recognition and excellent advice which proved invaluable to him. He attributed to the same great painter the criticism that "he had learnt too much from the old masters and would benefit by the training of an art school." A few days afterwards he pro-

duced a most amusing caricature of himself being kicked down the stairs of the National Gallery by Raphael, Titian, and Mantegna, whilst Michael Angelo dealt a blow on his head with a hammer. This entertaining little record, I am sorry to say, was destroyed. Beardsley was always sensible about friendly and intelligent criticism. When he reached a position enjoyed by no artist of his own age, he was swift to remedy any defect pointed out to him by artists or even by ordinary friends. I never met anyone so receptive on all subjects; he would record what Mr Pennell or Puvis de Chavannes said in praise or blame of a particular drawing with equal candour and good humour. This was only one of his many amiable qualities. When he afterwards became a sort of household word and his fame, or notoriety as his enemies called it, was established, he never changed in this respect. He made friends and remained friends with many for whom his art was totally un-intelligible. Social charm triumphed over all differences. He would speak with enthusiasm about writers and artists quite out of sympathy with his own aims and aspirations. He never assumed that those to whom he was intro-

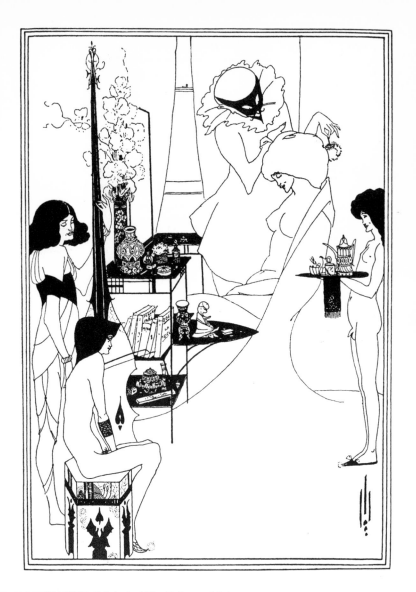

SALOME: Original of The Toilette of Salome.

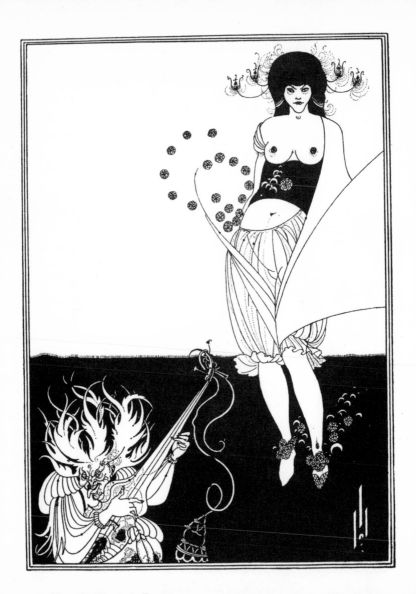

SALOME: The Belly Dance.

duced either knew or admired his work. His character was brisk and virile to an extraordinary degree. He made enemies, I believe, by refusing to revolve in mutual admiration societies or to support literary and artistic cliques. With the shadow of death always over him and conscious of the brief time before him, he never gave himself up to morbid despair or useless complaints. He determined to enjoy life, and, equipped with all the curiosity and gaiety of boyhood, he caught at life's exquisite moments. There was always a very deep and sincere religious vein in his temperament, only noticeable to very intimate friends. With all his power of grasping the essential and absorbing knowledge, he remained charmingly unsophisticated. He took people as they came, never discriminating, perhaps, sufficiently the issues of life. He was unspoiled by success, unburdened with worldly wisdom. He was generous to a fault, spending his money lavishly on his friends to an extent that became almost embarrassing.

His love and knowledge of books increased rather than diminished even after he devoted himself entirely to art. In early days he would exchange his drawings for illustrated

books and critical texts of the English classics
with Mr Frederick Evans, an early and en-
thusiastic buyer of his work. His tastes were
not narrow. Poetry, memoirs, history, short
stories, biography, and essays of all kinds
appealed to him ; but he cared little for
novels, except in French. I don't think he
ever read Dickens, Thackeray, and George
Eliot, though he enjoyed Scott during the
last months of his life. He had an early
predilection for lives of the Saints. The
scrap-book of sketches, containing drawings
done prior to 1892, indicates the range and
extent of his taste. There are illustrations
to "Manon Lescaut," "Tartarin," "Madame
Bovary," Balzac ("Le Cousin Pons," the "Contes
Drôlatiques"), Racine, Shelley's "Cenci." He
retained his love of the drama, and began to
write a play in collaboration with Mr Brandon
Thomas. While dominated by pre-Raphaelite in-
fluences, he read with great avidity "Sidonia the
Sorceress," and "The Shaving of Shagpat," a
favourite book of Rossetti's ; and it was with
a view to illustrate Mr Meredith's Arabian
Night that he became introduced to Mr John
Lane, who divides with Mr Herbert Pollitt the

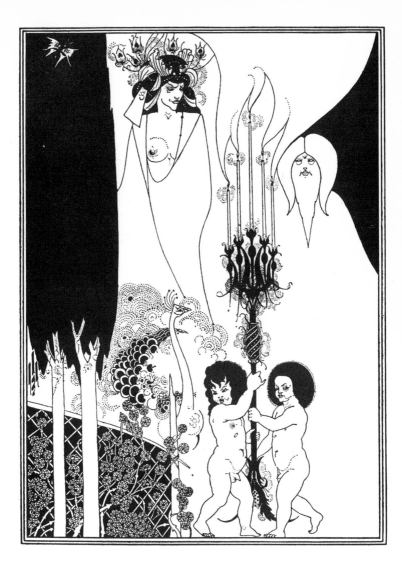

SALOME: Eyes of Herod.

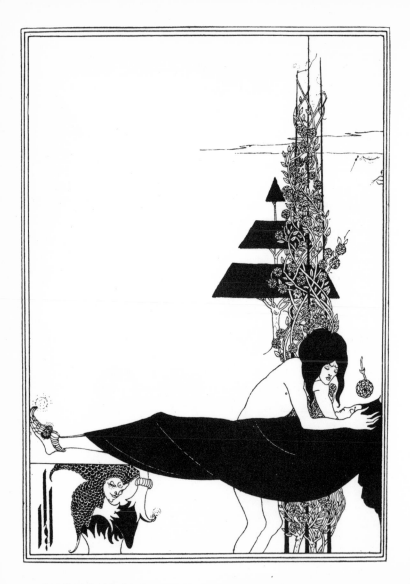

SALOME: A Platonic Lament.

honour of possessing the finest Beardsleys still in this country. He read Greek and Latin authors in translations, and often astonished scholars by his acute appreciation of their matter. He approached Dantesque mediæval-ism through Rossetti and, later on, at the original source. Much of his early work illustrated incidents in the " Divine Comedy." He was a fervent admirer of the " Romance of the Rose " in the original, and several mediæval French books, but he once told me that he found the " Morte d'Arthur " very long-winded.

For one so romantic in the expression of his art, I should say his literary and artistic tastes were severely classic, though you would have expected them to be bizarre. He was ambitious of literary success, but any aspirations were wisely discouraged by his admirers. His writings, however brilliant—and they often were brilliant —shewed a dangerous cleverness, which on culti-vation might have proved disastrous to the realization of his true genius. " Under the Hill " is a delightful experiment in a rococo style of literature, and it would be difficult to praise sufficiently the rhythm and metrical adroit-ness of the two poems in the Savoy Maga-

zine. Though I cannot speak of his musical attainments, it may be regarded as fortunate that so remarkable a genius was directed to a more permanent form of executive power.

His knowledge of life, art, and literature seemed the result of instinct rather than study; for no one has ever discovered where he found the time or opportunity for assimilating all he did. Gregarious and sociable by nature, he was amusingly secretive about his methods and times of work. Like other industrious men, he never pretended to be busy or pressed for time. He never denied his door to callers, nor refused to go anywhere on the plea of "work."

He disliked anyone being in the room when he was drawing, and hastily hid all his materials if a stranger entered the room. He would rarely exhibit an unfinished sketch, and carefully destroyed any he was not thoroughly satisfied with himself. He carried this sensitive spirit of selection and self-criticism rather far. Calling on friends who possessed primitives, he would destroy these early relics and leave a more mature and approved specimen of his art, or the *édition de luxe* of some book he had illustrated. Some of us were so annoyed that

THE LADY OF THE LAKE
TELLETH ARTHVR OF THE
SWORD EXCALIBVR

we were eventually obliged to lock up all early examples. For though friends thus victimized were endowed with a more valuable acquisition, they had a natural sentiment and affection for the unsophisticated designs of his earlier years.

His life, though many-sided and successful, was outwardly uneventful. In the early summer of 1892 he entered Professor Brown's night school at Westminster, but during the day continued his work at the Guardian Fire Insurance until August, when, by his sister's advice, he resigned his post. In December he became acquainted with Mr Pennell, from whose encouragement and advice he reaped the fullest advantage. After commencing the decorations to the "Morte d'Arthur," he ceased to attend Professor Brown's classes. In February 1893 some of his drawings were first published in London in the Pall Mall Budget under the editorship of Mr Lewis Hind, but one of the most striking of his early designs appeared in a little college magazine entitled The Bee. When The Studio was started by Mr Charles Holme under the able direction of the late Gleeson-White, Beardsley designed the first

cover and Mr Pennell contributed the well-known appreciation of the new artist.

Towards the end of 1893 he commenced working for Mr John Lane, who issued his marvellous illustrations to "Salomé" in 1894. In April of the same year appeared the Yellow Book. To the first four volumes Beardsley contributed altogether about eighteen illustrations. From a pictorial point of view this publication had no other *raison d'être* than as a vehicle for the production of Beardsley's work, though Henry Harland, in his capacity as literary editor, revealed the presence of many new writers among us. Throughout 1894 Beardsley's health seemed to improve, and his social success was considerable. In the previous year he had been ridiculed, but now the world accepted him at Mr Pennell's valuation. The Beardsley type became quite a fashion, and was burlesqued at many of the theatres; his name and work were on every one's lips. He made friends with many of his contemporaries distinguished in art and literature. At the house of one of his friends he delivered a very amusing lecture on "Art" which created much discussion.

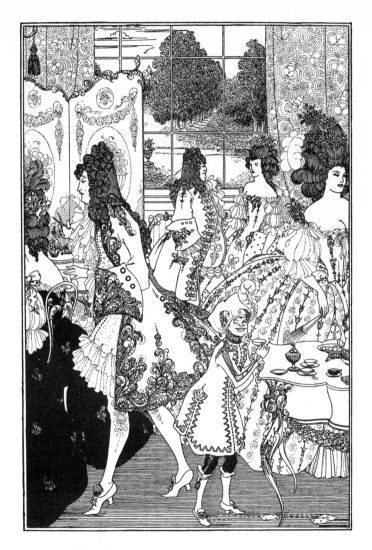

Rape of the Lock.

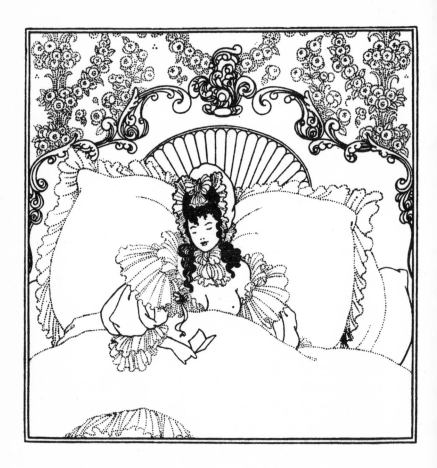

The Billet-Doux.

Aubrey Beardsley

A little later Beardsley was popularly supposed to have given pictorial expression to the views and sentiments of a certain school, and his drawings were regarded as the outward artistic sign of inward literary corruption. This is not the place to discuss the invention of a mare's nest. He suffered considerably by this premature attempt to classify his art. Further efforts to ridicule his work and suppress its publication were, however, among the most cheering failures of modern journalism. In 1895 he ceased to contribute to the Yellow Book, and in January 1896 The Savoy was started by Leonard Smithers, with Mr Arthur Symons as the literary editor, who became the most subtle and discerning of all his critics after Beardsley's death. Failing health was the only difficulty with which he had to contend in the future. From March 1896, when he caught a severe chill at Brussels, he became a permanent invalid. He returned to England in May, and in August went to Bournemouth, where he spent the autumn and winter.

Those who visited him at Bournemouth never expected he would live for more than a few weeks. His courage, however, never failed

him, and he continued work even while suffering from lung hæmorrhage; but he expressed a hope and belief, in which he was justified, that he might be spared one more year. On March 31st, 1897, he was received into the Catholic Church. The sincerity of his religious convictions has been affirmed by those who were with him constantly; and, as I have suggested before, the flippancy and careless nature of his conversation were superficial: he was always strict in his religious observances. Among his intimate friends through life were clergymen and priests who have paid tribute to the reality and sincerity of his belief.

A week after being received, Beardsley rallied again, and moved to Paris, but still required the attention and untiring devotion of his mother, to whom he was deeply attached. He never returned to England again. From time to time he was cheered by visits from Miss Mabel Beardsley (Mrs Bealby Wright), who understood her brother as few sisters have done. For some time he stayed at St Germain, and in July 1897 he went to Dieppe, where he seemed almost to have recovered. It was only, however, for a short time, and in the end of 1897 he

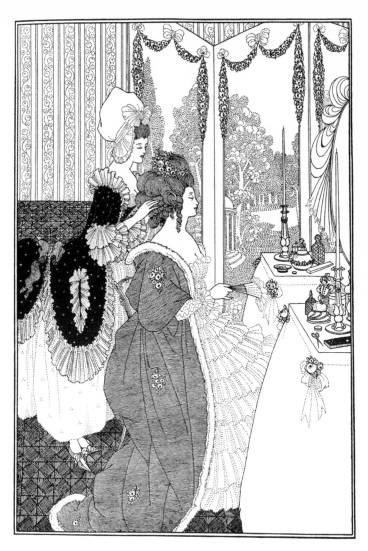

The Toilet.

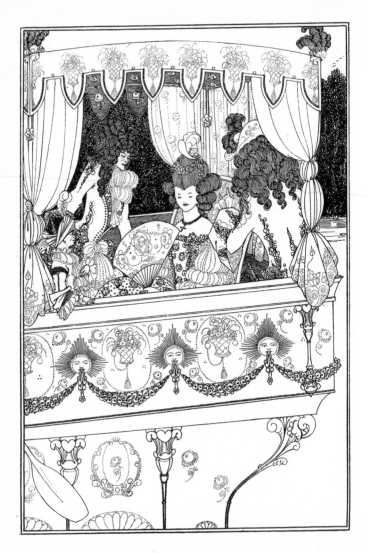

The Barge.

was hurried to Mentone. He never left his room after January 25th. The accounts of him which reached London prepared his friends for the end. Almost one of his last letters was to Mr Vincent O'Sullivan, the poet, congratulating him on his Introduction to "Volpone," for which Beardsley was making the illustrations. Beardsley had a considerable knowledge and appreciation of Ben Jonson.

On March 23rd, 1898, he received the last sacraments; and on the 25th, with perfect resignation, in the presence of his mother and sister, to whom he had confided messages of love and sympathy to his many friends, Aubrey Beardsley passed away.

> " Come back in sleep, for in the life
> Where thou art not
> We find none like thee. Time and strife
> And the world's lot
>
> Move thee no more : but love at least
> And reverent heart
> May move thee, royal and released
> Soul, as thou art."

No one could have wished him to live on in pain and suffering. I think the only great trials of his life were the periods in which he was

unfitted for work. His remarkable career was not darkened by any struggle for recognition. Few artists have been so fortunate as Aubrey Beardsley. His short life was remarkably happy—at all events during the six years he was before the public. Everything he did met with success—a success thoroughly enjoyed by him. He seemed indifferent to the idle criticism and violent denunciation with which much of his art was hailed. I never heard of anyone of importance who disliked him personally; on the other hand, many who were hostile and prejudiced about his art ceased to attack him after meeting him. This must have been due to the magnetism and charm of his individuality, exercised quite unconsciously, for he never tried to conciliate people, or "to work the oracle," but rather gloried in shocking "the enemy," a boyish failing for which he may be forgiven.

He had considerable intellectual vanity, but it never relapsed into common conceit. He was generous in recognizing the talent and genius of others, but was singularly perverse in some of his utterances. He said once that only four of his contemporaries interested him. He

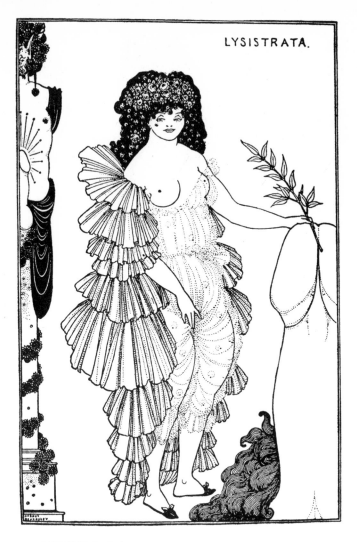

LYSISTRATA.

LYSISTRATA: Frontispiece.

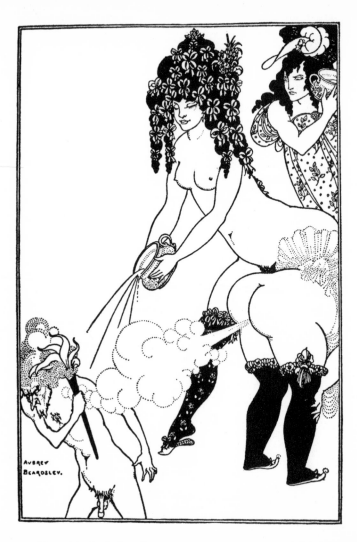

Women defending the Acropolis.

bore with extraordinary patience the asser-
tions of foolish persons who calmly asserted
that both in America and England other artists
had anticipated the peculiarities of his style and
methods. I have seen the works of these
Lambert Simnels and Perkin Warbecks, and
they proved, one and all, crows in peacocks'
feathers. Beardsley's style, nevertheless, in-
fluenced (unfortunately, I think) many excellent
artists both younger and older than himself.
In France his work was accepted without ques-
tion: he was always gratified by the cordiality
which greeted him in a country where he was
more generally understood than in his own.
He has illustrious precedents in Constable
and Bonnington. Italy, Austria, and Germany
recognized in him a master some time before
his death. At Berlin his picture of *Mrs
Patrick Campbell*, the actress, is now in a place
of honour in the Museum. A portrait study of
himself is in the British Museum Print Room;
a few examples are at South Kensington; but
all his important work is in private collections;
much of it is in America and Germany. In
England, putting aside the notoriety and sensa-
tion caused by his posters and the Yellow

Book, appreciation of his work has been confined rather to the few. He enjoyed, however, the friendship and intimacy of great numbers of people, shewing that his amiable qualities, no less than his art, received due recognition. His conversation was vehement and witty rather than humorous. He had a remarkable talent for mimicking, very rarely exercised. He loved argument, and supported theories for the sake of argument in the most convincing manner, leaving strangers with a totally wrong impression about himself, a deception to which he was much addicted. He possessed what is called an artificial manner, cultivated to an extent that might be mistaken for affectation. He never could sit still for very long, and he made use of gesture for emphasis. His peculiar gait has been very happily rendered in a portrait of him by Mr Walter Sickert; he also sat to M. Blanche, the well-known French portrait painter; the portrait by himself is tinged with caricature.

To estimate the art of Aubrey Beardsley is not difficult. That his drawings must excite discussion at all times is only a proof of their

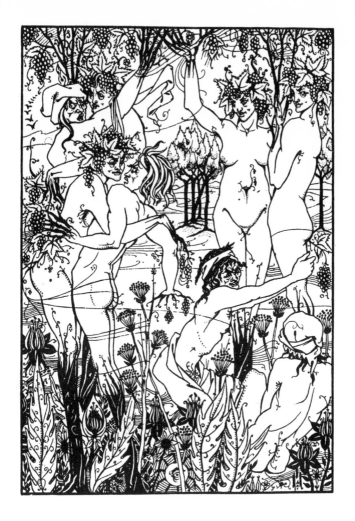

Suppressed Snare of Vintage for Lucian's True History.

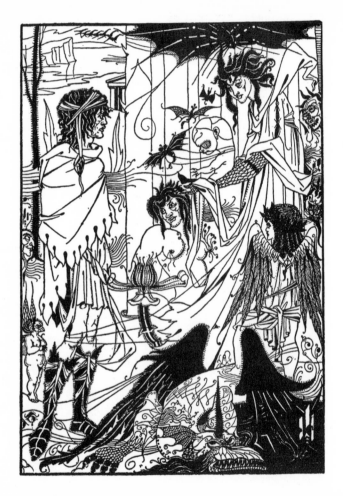

Dreams for Lucian's True History.

lasting worth. They can never be dismissed
with unkindly comment, nor shelved into the
limbo of art criticism which waits for many
blameless and depressing productions of the
eighteenth and nineteenth centuries. Among
artists and men of letters no less than with that
great inartistic body, "the art-loving public,"
Aubrey Beardsley's name will always call forth
wonder, admiration, speculation, and contempt.
It should be conceded, however, that his work
cannot appeal to everyone; and that many who
have the highest perception of the beautiful see
only the repulsive and unwholesome in the
troubled, exotic expression of his genius.
Fortunately, no reputation in art or letters
rests on the verdict of majorities—it is the
opinion of the few which finally triumphs.
Artists and critics have already dwelt on
the beauty of Aubrey Beardsley's line, which
in his early work too often resolved itself
into mere caligraphy; but the mature and
perfect illustrations to "Salomé" and "The
Rape of the Lock" evince a mastery unsur-
passed by any artist in any age or country.
No one ever carried a simple line to its in-
evitable end with such sureness and firmness

of purpose. And this is one of the lessons which even an accomplished draughtsman may learn from his drawings, in any age when scraggy execution masquerades under impressionism. Aubrey Beardsley did not shirk a difficulty by leaving lines to the imagination of critics, who might enlarge on the reticence of his medium. Art cant and studio jargon do not explain his work. It is really only the presence or absence of beauty in his drawing, and his wonderful powers of technique which need trouble his admirers or detractors. Nor are we confronted with any conjecture as to what Aubrey Beardsley might have done—he has left a series of achievements. While his early death caused deep sorrow among his personal friends, there need be no sorrow for an " inheritor of unfulfilled renown." Old age is no more a necessary complement to the realization of genius than premature death. Within six years, after passing through all the imitative stages of probation, he produced masterpieces he might have repeated but never surpassed. His style would have changed. He was too receptive and too restless to acquiesce in a single convention.

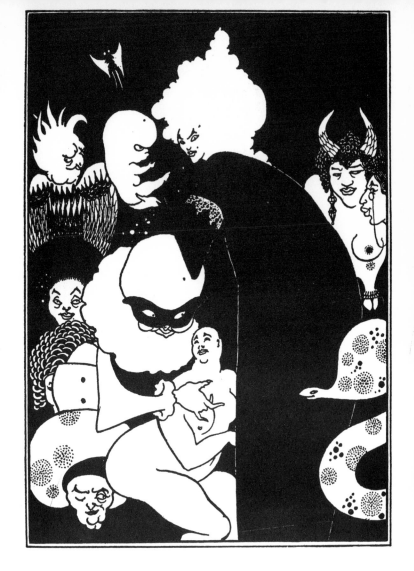

Lucian's Strange Creatures, Suppressed.

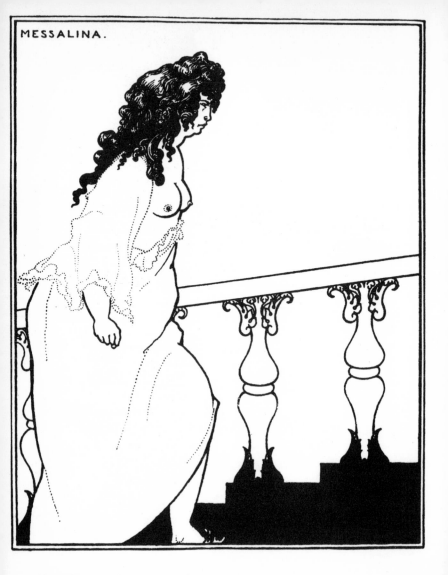

MESSALINA.

Messalina Returning.

This is hardly the place to dwell on the great strides which black and white art made in the nineteenth century. It has been called the most modern of the arts; for the most finished drawings of the old masters were done with a view to serve as studies or designs to be transferred to canvas, metal, and wood, not for frames at an expensive dealer's. Vittore Pisano and Gentile Bellini would hardly have dared to mount their delightful studies and offer them as pictures to the critics and patrons of their day. At all events it were safer to say, that appreciation of a drawing for itself, without relation to the book or page it was intended to adorn or destroy, is comparatively modern. It is necessary to keep this in mind, because the suitability of Beardsley's work to the books he embellished was often accidental. His designs must be judged independently, as they were conceived, without any view of interpreting or even illustrating a particular author. He was too subjective to be a mere illustrator. Profoundly interested in literature for the purposes of his art, he only extracted from it whatever was suggestive as pattern; he never professed to interpret for dull people, unable to understand what they read,

any more than the mediæval illuminator and carver of grotesques attempted to explain the mysteries of the Christian faith on the borders of missals and breviaries or the miserere seats of the choir. His art was, of course, intensely *literary*, to use the word hated of modern critics, but his expression of it was the legitimate literature of the artist, not the art peculiar to literature. He did not attempt, or certainly never succeeded in giving, pictorial revision to a work of literature in the sense that Blake has done for the book of Job, and Botticelli for the "Divine Comedy." While hardly satisfying those for whom any work of art guilty of "subject" becomes worthless, this immunity from the conventions of the illustrator will secure for Beardsley a larger share of esteem among artists pure and simple than has ever fallen to William Blake, who appeals more to men of letters than to the artist or virtuoso. The uncritical profess to find many terrible meanings in Aubrey Beardsley's drawings; and he will probably never be freed from the charge of symbolism. However morbid the sentiment in some of his work, and often there was a *macabre*, an unholy insistence on the less beauti-

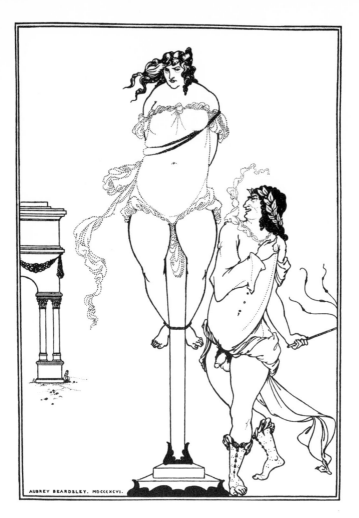

Juvenal Scourging Woman.

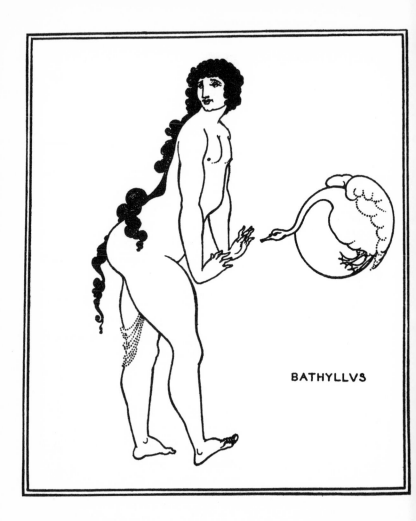

BATHYLLVS

Bathyllus' Swan Dance.

ful side of human things, the cabala of the symbolists was a sealed book to him. Such things were entirely foreign to his lucid and vigorous intelligence. There is hardly a drawing of his that does not explain itself; the commentator will search in vain for any hieroglyphic or symbolic intention. The hieratic archaism of his early work misled many people, for whom pre-Raphaelitism means presupposition. Of mysticism, that stumbling-block, he had none at all. "*The Initiation of a Neophyte into the Black Art*" would seem to contradict such a statement. The fantasy and grotesqueness of that lurid and haunting composition have nothing in common with the symbolism of black magic, the ritual of freemasonry, or all the fascinating magic to be found in the works of Eliphaz Levi. The sumptuous accessories in which he revelled had no other than a decorative intention, giving sometimes balance to a drawing, or conveying a literary suggestion necessary for its interpretation.

Artists are blamed for what they have not tried to do; or for the absence of qualities distinguishing the work of an entirely different order of intellect; for their indifference to the

observations of *others*. As who should ask
from Reynolds a faithful reproduction of textile
fabrics; and from Carlo Crivelli the natural
phenomena of nature we expect from Turner
and Constable? For nature as it should be, in
the works of Corot and Turner; for nature
made easy, in modern English landscape; for
nature without tears, in the impressionist fashion,
or as popularly viewed through the camera,
Aubrey Beardsley had no feeling. He was
frankly indifferent to picturesque peasants, the
beauties of "lovely spots," either in England or
France. A devout Catholic, the ringing of the
Angelus did not lure him to present fields of
mangel-wurzels in an evening haze. The
treatment of nature in the larger and truer sense
of the word had little attraction for him; he
never tried, therefore, to represent air, atmo-
sphere, and light, as many clever modern artists
have done in black and white! Though Claude,
that master of light and shadow, was a landscape
painter who really interested him. Beardsley's
landscape, therefore, is formal, primitive, con-
ventional; a breath of air hardly shakes the
delicate leaves of the straight poplars and
willows that grow by his serpentine streams.

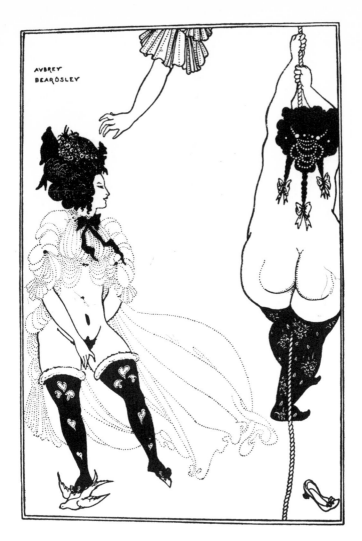

Trying to Get Away.

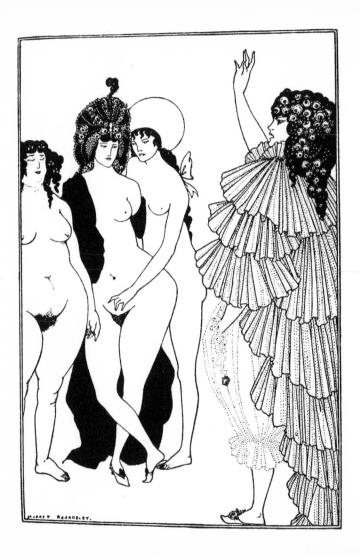

Aubrey Beardsley

The great cliffs, leaning down in promontories to the sea, have that unreal, architectural appearance so remarkable in the West of Cornwall, a place he had never visited. Yet his love and observation of flowers, trees, and gardens are very striking in the drawings for the " Morte d'Arthur " and the Savoy Magazine, but it is the nature of the landscape gardener, not the landscape painter. There is some truth in the half-playful, half-unfriendly criticism, that his pictures were a form of romantic map-making. Future experts, however, may be trusted to deal with absence of chiaroscuro, values, tones, and the rest. In only one of his drawings, conceived, curiously enough, in the manner of Burne-Jones (an unlikely model), is there anything approaching what is usually termed atmosphere. Eliminating, therefore, all that must not be expected from his art—mere illustration, realism, symbolism and naturalism—in what, may be asked, does his supreme achievement consist? He has decorated white sheets of paper as they have never been decorated before; whether hung on the wall, reproduced in a book, or concealed in a museum, they remain among the most

precious and exquisite works in the art of the
nineteenth century, resembling the designs of
William Blake only—in that they must be
hated, misunderstood, and neglected, ere they
are recognized as works of a master. With
more simple materials than those employed by
the fathers of black and white art, Beardsley
has left memorials no less wonderful than those
of the Greek vase-painters, so highly prized by
artists and archæologists alike, but no less
difficult for the uninitiated to appreciate and
understand.

The astonishing fertility of his invention, and
the amount of work he managed to produce,
were inconceivable; yet there is never any sign
of hurry; there is no scamping in his deft and
tidy drawing. The neatness of his most ela-
borate designs would suggest many sketches
worked over and discarded before deciding on
the final form and composition. Strange to say,
this was not his method. He sketched every-
thing in pencil, at first covering the paper with
apparent scrawls, constantly rubbed out and
blocked in again, until the whole surface
became raddled from pencil, indiarubber, and
knife; over this incoherent surface he worked

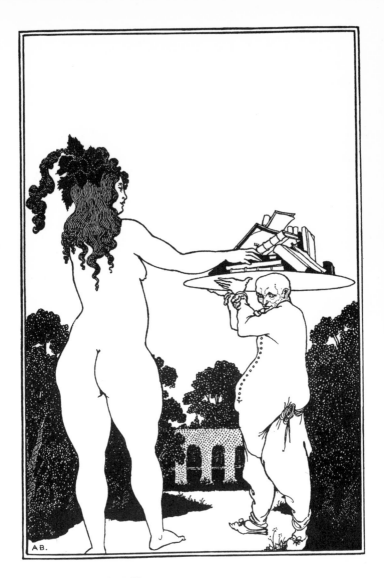

The Artist's Book Plate.

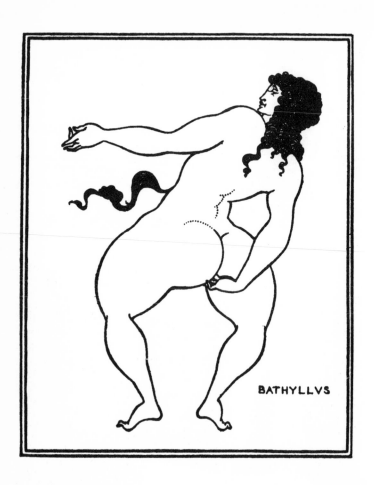

BATHYLLVS

Bathyllus Luring.

in Chinese ink with a gold pen, often ignoring the pencil lines, afterwards carefully removed. So every drawing was invented, built up, and completed on the same sheet of paper. And the same process was repeated even when he produced replicas. At first he was indifferent to process reproduction, but, owing to Mr Pennell's influence, he later on always worked with that end in view; thereby losing, some will think, his independence. But he had nothing to complain of—Mr Pennell's contention about process was never so well proved as in Beardsley's case. His experiments in colour were not always successful, two of his most delightful designs he ruined by tinting. In the posters and Studio lithograph, however, the crude colour is highly effective, and "*Mademoiselle de Maupin*" shewed he might have mastered water-colour had he chosen to do so. There are at present in the market many coloured forgeries of his work: these have been contrived by tracing or copying the reproductions; the colour is often used to conceal the paucity of the drawing and hesitancy of line; they are nearly always versions of well-known designs, and profess to be replicas.

Aubrey Beardsley

When there *is* any doubt the history and provenance of the work should be carefully studied. It is not difficult to trace the pedigree of any *genuine* example.

A good deal has been made out of Beardsley's love of dark rooms and lamp light, but this has been grossly exaggerated. He had no great faith in north lights and studio paraphernalia, so necessary for those who use mediums other than his own. He would sometimes draw on a perfectly flat table, facing the light, which would fall directly on the paper, the blind slightly lowered.

The sources of Beardsley's inspiration have led critics into grievous errors. He was accused of imitating artists, some of whose work he had never seen, and of whose names he was ignorant at the time the alleged plagiarism was perpetrated—Félicien Rops may be mentioned as an instance. Beardsley contrived a style long before he came across any modern French illustration. He was innocent of either Salon, the Rosicrucians, and the Royal Academy alike; but his own influence on the Continent is said to be considerable. That he borrowed freely and from every imaginable master, old and new,

The YELLOW BOOK: Comedy-Ballet of Marionettes II.

MISS TERRY.

Beardsley.

is, of course, obvious. Eclectic is certainly applicable to him. But what he took he endowed with a fantastic and fascinating originality; to some image or accessory, familiar to anyone who has studied the old masters, he added the touch of modernity which brings them nearer to us, and reached refinements never thought of by the old masters. Imagination is the great pirate of art, and with Beardsley becomes a pretext for invention.

Prior to 1891 his drawings are interesting only for their precocity; they may be regarded, as one of his friends has said, more as a presage than a precedent. You marvel, on realizing the short interval which elapsed between their production and the masterpieces of his maturity. His first enthusiasm was for the work of the Italian primitives, as Mr Charles Whibley says, distinguished "for its free and flowing line." Even at a later time, when he devoted himself to eighteenth century models and ideals, his love of Andrea Mantegna never deserted him. He always kept reproductions from Mantegna at his side, and declared that he never ceased to learn secrets from them. In the "*Litany of Mary Magdalen*" and the two

versions of "*Joan of Arc*" this influence is very marked. A Botticelli phase followed, and though afterwards discarded, was reverted to at a later period. The British Museum and the National Gallery were at first his only schools of art. As a matter of course, Rossetti and Burne-Jones, but chiefly through photographs and prints, succeeded in their turn; the influence of Burne-Jones lasting longer than any other.

Fairly drugged with too much observation of old and modern masters, he entered Professor Brown's art school, where he successfully got rid of much that was superfluous. The three months' training had the most salutary effect. He now took the advice attributed to Burne - Jones, and unlearned much of his acquired pedantry. The mere penmanship which disfigured some of his early work entirely disappeared. His handling became finer, his drawing less timid. The sketch of *Molière*, it may be interesting to note, belongs to this period of his art.

A few months afterwards, he commenced the "Morte d'Arthur." Suggested and intended to rival the volumes of the Kelmscott Press, it is

Siegfried.

his most popular and least satisfactory performance. Still the borders have far more variety and invention than those of Morris; the intricate splendours of mediæval manuscripts are intelligently imitated or adapted. The initial- and tail-pieces are delightful in themselves, and among the most exquisite of his grotesques and embellishments. But the popularity of the book was due to its lack of originality, not to its individuality. Mediævalism for the middle classes always ensures an appreciative audience. Oddly enough, Morris was said to be annoyed by the sincerest form of flattery. Perhaps he felt that every school of art comes to an end with the birth of the founder, and that Beardsley was only exercising himself in an alien field of which Morris himself owned the tithe. At all events it is not unlikely that Beardsley aroused in the great poet and decorator the same suspicion that he had undoubtedly done in Watts.

The "Morte d'Arthur" may be said, for convenience, to close Aubrey Beardsley's first period; but he modified his style during the progress of the publication, and there is no unity of intention in his types or scheme of

decoration. He was gravitating Japanwards. He began, however, his so-called Japanesques long before seeing any real Japanese art, except what may be found in the London shop windows on cheap trays or biscuit-boxes. He never thought seriously of borrowing from this source until some one not conversant with Oriental art insisted on the resemblance of his drawings to Kakemonos. It was quite accidental. Beardsley was really studying with great care and attention the Crivellis in the National Gallery; their superficial resemblance to Japanese work occasioned an error from which Beardsley, quick to assimilate ideas and modes of expression, took a suggestion, unconsciously and ignorantly offered, and studied genuine examples. " *Raphael Sanzio* " (first version) was produced prior to this incident, and " *Madame Cigale's Birthday Party* " immediately afterwards. His emulation of the Japanese never left him until the production of the Savoy Magazine. In my view this was the only bad artistic influence which ever threatened to endanger his originality, or permanently vitiate his manner. The free use of Chinese ink, together with his intellectual vitality, saved

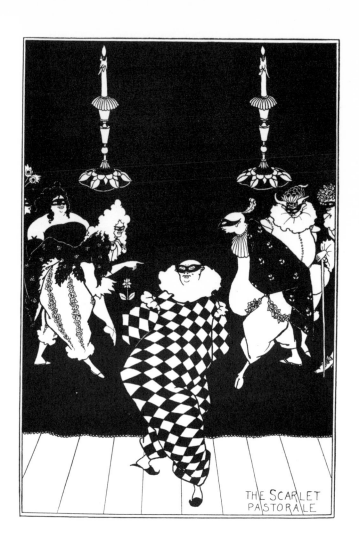

THE SCARLET
PASTORALE

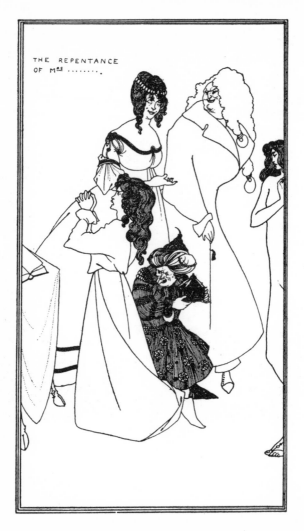

The YELLOW BOOK: Repentance of Mrs.

him from "succumbing to Japan," to use Mr Pennell's excellent phrase.

A series of grotesques to decorate some rather silly anthologies produced in the same year as the "Morte d'Arthur" are marvels of ingenuity, and far more characteristic. With them he began a new period, throwing over the deliberate archaism and mediævalism, of which he began to tire. In the illustrations to "Salomé," he reached the consummation of the new convention he created for himself; they are, collectively, his masterpiece. In the whole range of art there is nothing like them. You can trace the origin of their development, but you cannot find anything wherewith to compare them; they are absolutely unique. Before commencing "Salomé" two events contributed to give Beardsley a fresh impetus and stimulate his method of expression: a series of visits to the collection of Greek vases in the British Museum (prompted by an essay of Mr D. S. McColl), and to the famous Peacock Room of Mr Whistler, in Prince's Gate—one the antithesis of Japan, the other of Burne-Jones. Impressionable at all times to novel sensations, his artistic perceptions vibrated with

a new and inspired enthusiasm. Critical appreciation under his pen meant creation. From the Greek vase painting he learned that drapery can be represented effectually with a few lines, disposed with economy, not by a number of unfinished scratches and superfluous shading. If the "Salomé" drawings have any fault at all, it is that the texture of the pictures suggests some other medium than pen and ink, as Mr Walter Crane has pointed out in his other work. They are wrought rather than drawn, and might be designs for the panel of a cabinet, for Limoges or Oriental enamel. "The Rape of the Lock" is, therefore, a more obvious example of black and white art. Beardsley's second period lasted until the fourth volume of the Yellow Book, in which the "*Wagnerites*" should be mentioned as one of the finest. In 1896 Beardsley, many people think to the detriment of his style, turned his attention to the eighteenth century, in the literature of which he was always deeply interested. Eisen, Moreau, Watteau, Cochin, Pietro Longhi, now became his masters. The alien romantic art of Wagner often supplied the theme and subject. The level of excellence sustained throughout the Savoy Magazine

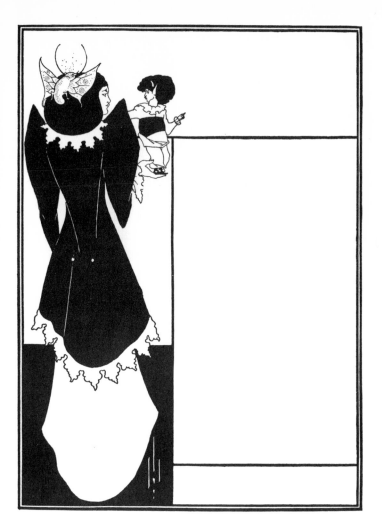

The YELLOW BOOK: Poster.

The YELLOW BOOK: Madame Réjane.

is extraordinary, in view of the terrible state of his health. His unexampled precision of line hardly ever falters; and while his composition gains in simplicity, his capacity for detail has not flagged. It is, perhaps, an accident that in his most pathetic drawing, "*The Death of Pierrot,*" his hand seems momentarily to have lost its cunning. The same year he gave us "The Rape of the Lock," regarded by some artists as the testament of his genius; and an even more astonishing set of drawings to the "Lysistrata" of Aristophanes. These are grander than the "Rape of the Lock," and larger in treatment than anything he ever attempted. Privately issued, Beardsley was able to give full rein to a Rabelaisian fantasy, which he sometimes cultivated with too great persistence. Irritated by what he considered as over-niceness in some of his critics, he seemed determined to frighten his public. There is nothing unwholesome or suggestive about the "Lysistrata" designs: they are as frank, free, and outspoken as the text. For the countrymen of Chaucer to simulate indignation about them can only be explained "because things seen are greater than things heard." Yet, when an artist frankly deals

with forbidden subjects, the old canons regular of English art begin to thunder, the critics forget their French accent; the old Robert Adam, which is in all of us, asserts himself; we fly for the fig-leaves. A real artist, Beardsley has not burdened himself with chronology or archæology. Conceived somewhat in the spirit of the eighteenth century, the period of graceful indecency, there is here, however, an Olympian air, a statuesque beauty, only comparable to the antique vases. The illusion is enhanced by the absence of all background, and this gives an added touch of severity to the compositions.

Throughout 1896 the general tendency of his style remains uniform, though without sameness. He adapted his technique to the requirements of his subject. Mindful of the essential, rejecting the needless, he always realized his genius and its limitations. From the infinite variety of the Savoy Magazine it is difficult to choose any of particular importance: for his elaborate manner, the first plate to "*Under the Hill*"; and in a simpler style, the fascinating illustration to his own poem, "*The Barber*"; "*Ave Atque Vale*" and "*The Death of Pierrot*" have, besides, a human interest

The YELLOW BOOK: Cover Design, Volume I.

over and above any artistic quality they possess. For the "Volpone" drawings Beardsley again developed his style, and seeking for new effects, reverted to pure pencil work. The ornate, delicate initial letters, all he lived to finish, must be seen in the originals before their sumptuous qualities, their solemn melancholy dignity, their dexterous handling, can be appreciated. The use of a camel's-hair brush for the illustrations to "*Mademoiselle de Maupin*," one of his last works, should be noted, as he so rarely used one. Beardsley's invention never failed him, so that it is almost impossible to take a single drawing, or set of drawings, as typical of his art. Each design is rather a type of his own intellectual mood.

If the history of grotesque remains to be written, it is already illustrated by his art. A subject little understood, it belongs to the dim ways of criticism. There is no canon or school, and the artist is allowed to be wilful, untrammelled by rule or precedent. True grotesque is not the art either of primitives or decadents, but that of skilled and accomplished workmen who have reached the zenith of a peculiar convention, however confined and limited that con-

vention may be. Byzantine art, one of our links with the East, should some day furnish us with a key to a mystery which is now obscured by symbolists and students of serpent worship. The Greeks, with their supreme sanity and unrivalled plastic sense, afford us no real examples, though their archaic art is often pressed into the category. Beardsley, who received recognition for this side of his genius, emphasized the grotesque to an extent that precluded any popularity among people who care only for the trivial and " pretty." In him it was allied to a mordant humour, a certain fescennine abstraction which sometimes offends : this, however, does not excuse the use of the word "eccentric," more misapplied than any word in the English language, except perhaps " grotesque " and "picturesque." All great art is eccentric to the conservative multitude. The decoration on the Parthenon was so eccentric that Pheidias was put in prison. The works of Whistler and Burne-Jones, once derided as eccentric, are now accepted as the commencement of great traditions. All future art will be dubbed eccentric, trampled on, and despised ; even as the first tulip that blossomed in England was

The YELLOW BOOK: Design for Title Page.

The YELLOW BOOK: Cover Design, Volume III.

rooted out and burnt for a worthless weed by the conscientious Scotch gardener.

To compare Beardsley with any of his contemporaries would be unjust to them and to him. He belonged to no school, and can leave no legend, in the sense that Rossetti, Whistler, and Professor Legros have done ; he proclaimed no theory ; he left no counsel of perfection to those who came after him. In England and America a horde of depressing disciples aped his manner with a singular want of success ; while admirable and painstaking artists modified their own convictions in the cause of unpopularity with fatal results. The sensuous charm of Beardsley's imagination and his mode of expression have only a superficial resemblance to the foreign masters of black and white. He continued no great tradition of the 'sixties ; has nothing in common with the inventive and various genius of Mr Charles Ricketts ; nothing of the pictorial propriety that distinguishes the work of his friend, Mr Pennell, or the homogeneous congruity of Boyd Houghton, Charles Keene, and Mr Frederic Sandys. He made use of different styles where other men employed different mediums. Unperplexed by painting

or etching or lithography, he was satisfied with the simplest of all materials, attaining therewith unapproachable executive power. Those who cavil at his flawless technique ignore the specific quality of drawing characterising every great artist. The grammar of art exists only to be violated. Its rules can be learnt by anyone. Those who have no artistic perception invariably find fault with the perspective, just as those who cannot write a well-balanced sentence are always swift to detect faults in grammar or spelling. There are, of course, weaknesses in the extremities of Beardsley's figures—the hands and feet being interruptions rather than continuations of the limbs. Occasional carelessness in this respect is certainly noticeable, and the structure of his figures is throughout capricious. It was no fault in his early work ; the hands and feet in the "*Joan of Arc*," if crude and exaggerated, being carefully modelled. While the right hand of "Salomé" in "*The Dancer's Reward*," grasping the head of the Baptist, is perfectly drawn, the left is feeble, when examined closely. For sheer drawing nothing can equal the nude figure in the colophon to "Salomé." The outstretched, quivering hands

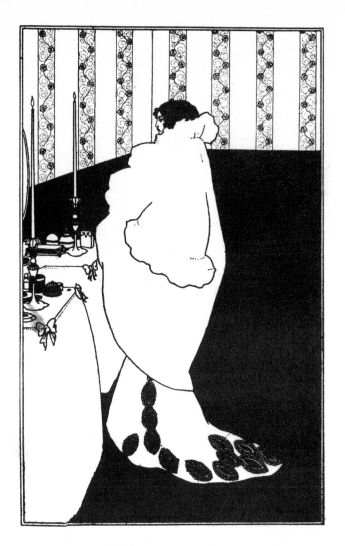

The YELLOW BOOK: La Dame aux Camelias.

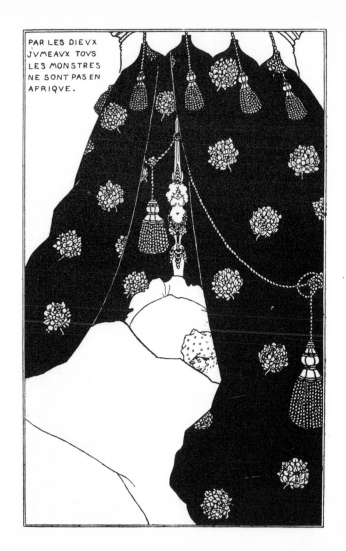

The YELLOW BOOK: Self Portrait.

of *Ali Baba* are intentionally rendered larger than proportion allows, to render dramatic expression, not reality. For the purpose of effect he adapted proportions, realizing that perfect congruity and reality are irreconcilable. None of the figures in the dramatic " *Battle of Beaux and Belles* " could sit on the fallen chair in the foreground.

There is no need to disturb ourselves with hopes and fears for the estimation with which posterity will cherish his memory; art history cannot afford to overlook him; it could hardly resist the pretext of moralising, expatiating and explaining away so considerable a factor in the book illustration of the nineties. As a mere comment on the admirations of the last twenty years of the nineteenth century, Beardsley is invaluable; he sums up all the delightful manias, all that is best in modern appreciation—Greek vases, Italian primitives, the "Hypnerotomachia," Chinese porcelain, Japanese Kakemonos, Renaissance friezes, old French and English furniture, rare enamels, mediæval illumination, the *débonnaire* masters of the eighteenth century, the English pre-Raphaelites. There are differences of kind in æsthetic beauty, and for Beardsley it

was the marriage of arabesque to figures and objects comely or fantastic, or in themselves ugly. For hitherto the true arabesque abhorred the graven image made of artists' hands. To future draughtsmen he will have something of the value of an old master, studied for that fastidious technique which critics believed to be a trick; and collectors of his work may live to be rallied for their taste; but the wheat and the chaff contrive to exist together through the centuries.

A passing reference should be made to the Beardsley of popular delusion. A student of Callot and Hogarth, he took suggestions from the age in which he lived and from the literature of English and French contemporaries, but with no implicit acceptance of the tenets of any groups or schools which flutter the dove-cots of Fleet Street. He stood apart, independent of the shibboleths of art and literature, with the grim and sometimes mocking attention of a spectator. He revealed rather than created a feminine type, offering no solution for the problems of Providence.

Applying the epithet "original" to an art so intensely reminiscent, so ingeniously retro-

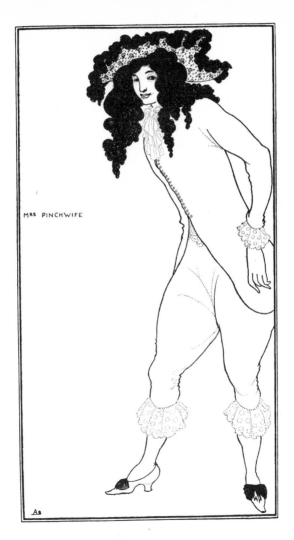

MRS PINCHWIFE

SAVOY: Mrs. Pinchwife.

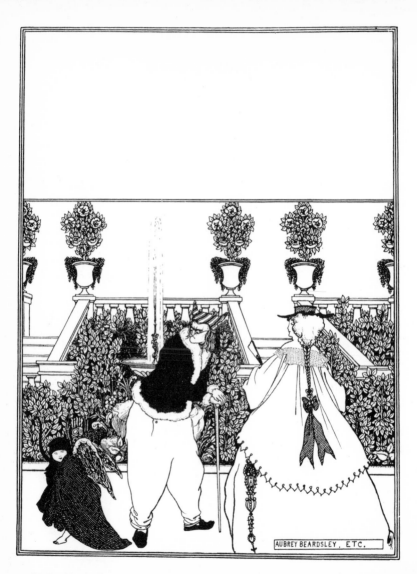

AUBREY BEARDSLEY, ETC.

SAVOY Cover Design 3.

spective, might seem paradoxical to those unacquainted with Beardsley's more elegant achievements. His is not the originality of Corot and Whistler, with a new interpretation of nature, another scheme of art and decoration, but rather the scholarly originality of the Carracci—a scholarship grounded on a thousand traditions and yet striking an entirely new note in art. In his imagination, his choice of motive, his love for inanimate nature, his sentiment for accessory,—rejected by many modern artists, still so necessary to the modern temper, —his curious type, which quite overshadowed that of the pre-Raphaelites, the singular technical qualities at his command, Beardsley has no predecessors, no rivals. Who has ever managed to suggest such colour in masses of black deftly composed? Reference to the text is unnecessary to learn that the hair of Herodias was purple. His style was mobile, dominating over, or subordinate to the subject, as his genius dictated. He twisted human forms, some will think, into fantastic peculiar shapes, becoming more than romantic—antinomian. He does not appeal to experience but to expression. The tranquil trivialities of what is usually

understood by the illustration of books had no meaning for him ; and before any attempt is made to discriminate and interpret the spirit, the poetical sequence, the literary inspiration which undoubtedly existed throughout his work, side by side with technical experiments, his exemption from the parallels of criticism must be remembered duly.

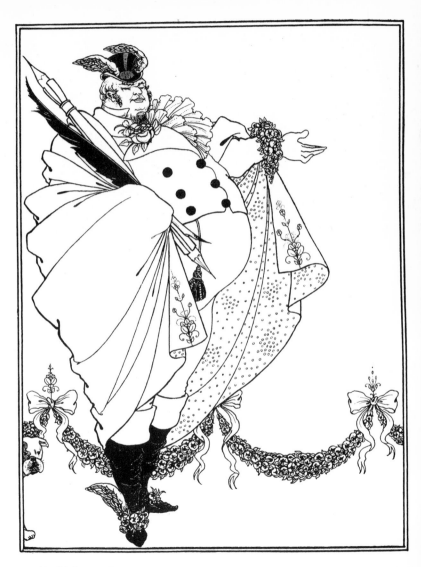

SAVOY: Contents Page.

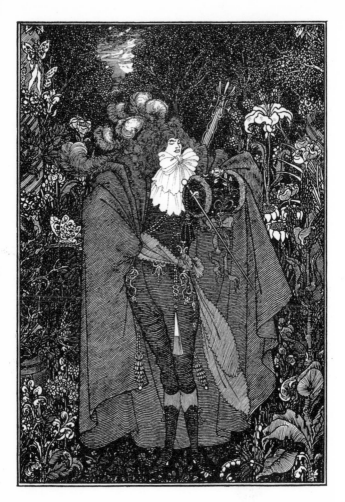

SAVOY: The Abbe in Under the Hill.

LIST OF DRAWINGS BY AUBREY BEARDSLEY

JUVENILIA

1. A CARNIVAL. Long procession of many figures in fifteenth and sixteenth century costume. Water-colour drawing. Unpublished. Given by the artist to his grandfather, the late Surgeon-Major William Pitt. *c.* 1880.

2. THE JACKDAW OF RHEIMS, set of illustrations to the poem. Unpublished. *c.* 1884.

3. VIRGIL's "ÆNEID," nine comic illustrations to Book II. The title-page, written in rough imitation of printing, with the Artist's naïf and inaccurate spelling, is as follows:—ILLUSTRATIONES DE | LIBER SECUNDUS | ÆNEIDOS | PUBLIUS WIRGIUS MARONIS | by | Beardslius | de | Brightelmstoniensis. The illustrations are entitled:—

 I. Laocoon hurleth his spear against the horse.
 II. Laocoon and son crunched up.
 III. Little July tries to keep up with Papa. Old Father Anchises sitteth on Papa's shoulders and keeps a good look-out.
 IV. Parvi Iulus.
 V. Helen.
 VI. Panthus departs, bag and baggage.
 VII. Sinon telleth his tale unto King Priam.

VIII. One of the cinders of Illium.

IX. (No title.) The drawing, to illustrate two comic verses written at the top of the paper, represents Æneas being carried up into the air by means of a balloon attached to his helmet.

All the above are drawn in ordinary ink upon plain white paper of the kind used for rough work at the school, and all are of uniform size, $7\frac{1}{4} \times 5$ inches, except No. 9, which is on a double-size sheet, measuring $7\frac{1}{4} \times 10$ inches. Unpublished. (Property of H. A. Payne, Esq.) September to December 1886.

4. VIRGIL's "ÆNEID," nineteen humorous sketches illustrative of Book II., entitled :—

 I. Æneas relateth the tale to Dido.

 II. Laocoon hurls the spear.

 III. Sinon is brought before Priam.

 IV. Calchas will not betray anyone.

 V. "All night I lay hid in a weedy lake."

 VI. The Palladium is snatched away.

 VII. The Palladium jumpeth.

 VIII. Laocoon sacrificeth on the sand.

 IX. Sinon opens the bolt.

 X. Hector's ghost.

 XI. Æneas heareth the clash of arms.

 XII. Panthus fleeth.

 XIII. Pyrrhus exulteth.

 XIV. Death of Priam.

 XV. Æneas debateth whether he shall slay Helen.

 XVI. Venus appeareth to Æneas.

 XVII. Jupiter hurls the lightning.

 XVIII. Æneas and company set out from Troy.

 XIX. Æneas seeth Creusa's ghost.

LIST OF DRAWINGS
BY AUBREY BEARDSLEY
COMPILED BY AYMER VALLANCE

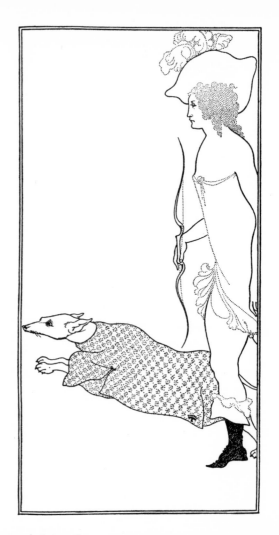

Atalanta II.

The above drawings in ordinary ink are contained in a copy-book, 8 × 6½ inches. Unpublished. Exhibited in London at Carfax & Co.'s Galleries, October 1904. (Property of Harold Hartley, Esq.) End of 1886.

5. THE POPE WEIGHS HEAVILY ON THE CHURCH. Pendrawing contained in the same copy-book with the last-named.

6. JOHN SMILES, a comic illustration to the school history book, representing King John in the act of signing Magna Charta. Pen-drawing on paper 7¼ × 5 inches. Unpublished. (Property of H. A. Payne, Esq.)

7. SAINT BRADLAUGH, M.P., a caricature. Pen-drawing on a half sheet of notepaper. Unpublished. (Property of H. A. Payne, Esq.)

8. AUTUMN TINTS. Caricature in black and white of the artist's schoolmaster, Mr Marshall, expounding to his pupils the beauties of nature. Unpublished. Given to Ernest Lambert, Esq., Brighton. *c.* 1886-7.

Beside the above-named there must have been numbers of such drawings belonging to this early period; for in his schooldays Aubrey Beardsley was, to quote the words of Mr H. A. Payne, "constantly doing these little, rough, humorous sketches, which he gave away wholesale." Many have been destroyed or lost, others dispersed abroad. Thus, for instance, one old Brighton Grammar School boy, C. E. Pitt-Schenkel, told Mr Payne that he was in possession of some, which he took out to South Africa.

9. The Jubilee Cricket Analysis. Eleven tiny pen-and-ink sketches, entitled respectively :—

 i. A good bowler.

 ii. Over.

 iii. Slip.

 iv. Square leg.

 v. Shooters.

 vi. Caught.

 vii. A block.

 viii. A demon bowler.

 ix. Stumped.

 x. Long leg.

 xi. Cutting a ball.

All these subjects being represented, in humorous fashion, by literal equivalents. These drawings, though they cannot pretend to any merit, are notable as the earliest specimens to be published of the artist's work. Together they formed a whole-page photo-lithographic illustration in *Past and Present*, the Brighton Grammar School Magazine, June 1887.

10. Congreve's "Double Dealer," illustration of a scene from, comprising Maskwell and Lady Touchwood. Pen drawing with sepia wash, on a sheet of paper $13\frac{1}{2} \times 11$ inches. Unpublished. (Property of H. A. Payne, Esq.) Signed and dated June 30, 1888.

11. Holywell Street. Wash drawing. First published in *The Poster*, Aug. - Sept. 1898. Republished in "The Early Work of Aubrey Beardsley, with a Prefatory Note by H. C. Marillier." John Lane, March 1899. (Property of Charles B. Cochran, Esq., 1888.)

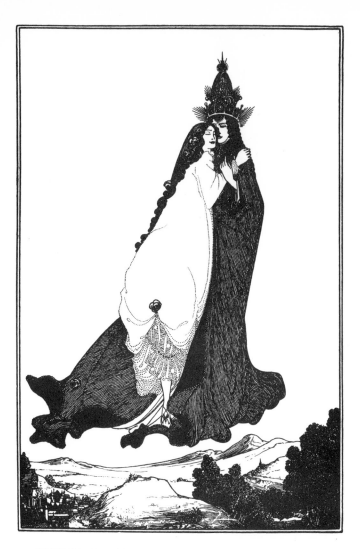

SAVOY: Saint Rosa of Lima.

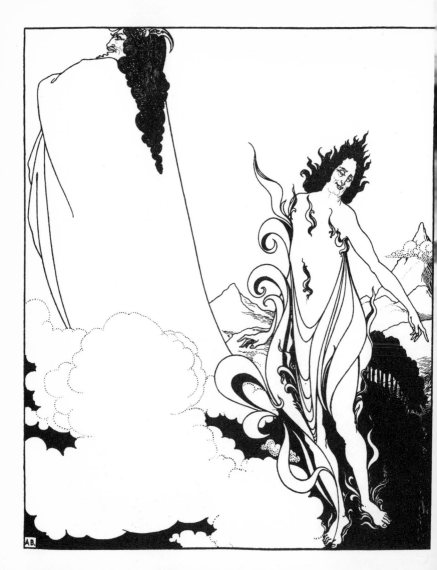

SAVOY: Fourth Tableau of "Das Rheingold"

12. THE PAY OF THE PIED PIPER: A LEGEND OF HAMELIN
TOWN. Eleven line drawings in illustration of, as
follows:—

 I. Entrance of Councillors, headed by Beadle
carrying a mace. Reproduced in *The West-
minster Budget*, March 25, 1898.

 II. Rats feeding upon a cheese in a dish. Repro-
duced in *Westminster Budget*, March 25, 1898.

 III. Child climbing into an armchair to escape from
the rats. Reproduced in *The Poster*, Aug.-
Sept. 1898.

 IV. The Sitting of the Council, under the presidency
of the Burgomaster.

 V. Deputation of Ladies.

 VI. Two rats on their hind legs, carrying off the
Beadle's mace: behind them are three rats
running. Reproduced in *Westminster Budget*,
March 25, 1898.

 VII. Meeting between the Beadle and the Piper.

 VIII. The rats follow the Piper out of the town. Re-
published in *Westminster Budget*, March 25,
1898, and in *The Poster*, Aug.-Sept. 1898.

 IX. Citizens rejoice at the departure of the rats.

 X. The Piper is dismissed by the Beadle. Re-
published in *Westminster Budget*, March 25,
1898, and also in *Magazine of Art*, May
1898.

 XI. The Piper entices away the children.

The above illustrations vary in size from $3\frac{1}{4} \times 2\frac{1}{2}$ to
$6\frac{1}{2} \times 4\frac{1}{2}$ inches. They are unsigned, but a prefatory
note describes them as being "the perfectly original
designs and drawings of a boy now in the school,

A. V. Beardsley"; and adds: "Our regret is that, lacking experience in the preparation of drawings for the photo-engraver, the reproductions should fall so far short of the original sketches." Published in the programme and book of words of the Brighton Grammar School Annual Entertainment at the Dome, on Wednesday, Dec. 19, 1888; bound up afterwards with *Past and Present*, February 1889. Latter part of 1888.

13. A SCRAP-BOOK, size $9\frac{1}{2} \times 7$ inches, the fly-leaf inscribed, in his own writing, *A. Beardsley*, 6/5/90, presented by the artist's mother to Robert Ross, Esq. Contains the following drawings, mounted as scraps:—

 i. Manon Lescaut, three drawings to illustrate different scenes from. Executed with very fine pen and ink, the latter having, as compared with maturer works, a brownish tinge. One of them first appeared in "A Second Book of Fifty Drawings by Aubrey Beardsley" (Leonard Smithers, December 1898), and all three were included in "The Later Work of Aubrey Beardsley" (John Lane, 1901).

 ii. La Dame aux Camélias. $4\frac{3}{8}$ inches square, pen and brownish ink with wash. First published in "Second Book," and afterwards in "Later Work." This is a totally different design from that which afterwards appeared, with the same title, in "The Yellow Book." See below.

 iii. Tartarin, two illustrations of, in pencil and colours, size $4\frac{1}{8} \times 2\frac{3}{4}$ and $4\frac{1}{2} \times 3\frac{1}{2}$ inches respectively.

 iv. La Leçon (Madame Bovary). $5\frac{1}{4} \times 6\frac{3}{4}$. Chinese

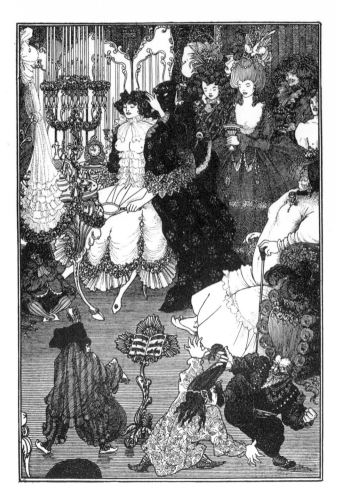

SAVOY: The Toilet of Helen (Venus)

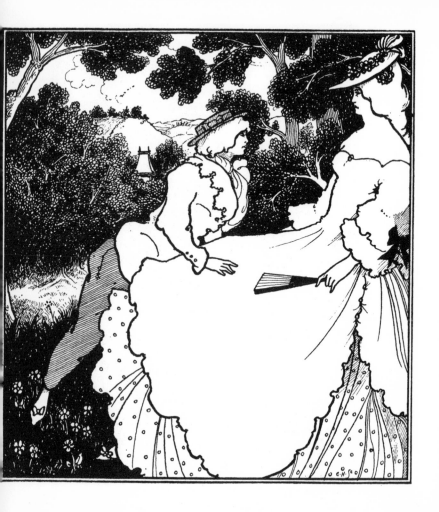

SAVOY: The Three Musicians, Suppressed.

white and dark sepia wash. First published in
"Second Book," and again in "Later
Work."

v. L'Abbé Birotteau (Curé de Tours). 3×2 inches.
Pen-and-ink with wash, on pale greenish paper.

vi. L'Abbé Troubert (Curé de Tours). $5 \times 2\frac{3}{4}$ inches.
Dark sepia wash.

vii. Madame Bovary. $5\frac{5}{8} \times 3\frac{1}{8}$ inches. Pencil. First
published in "Second Book," and again in
"Later Work."

viii. Sapho (Daudet). Wanting. Over its place has
been gummed another drawing, also wanting, its
title written at the foot, *L'homme qui rit*.

ix. Le Cousin Pons. $5\frac{1}{8} \times 2\frac{3}{8}$ inches. Indian
ink.

x. Portrait of Alphonse Daudet. $2\frac{3}{4} \times 2\frac{3}{16}$ inches.
Indian ink on pale blue paper.

xi. Watteau, Ma Cousine (Cousin Pons). $5\frac{1}{2} \times 2\frac{3}{4}$
inches. Pen-and-ink with wash on pale grey
toned paper.

xii. Mademoiselle Gamard (Curé de Tours). $3\frac{1}{8} \times 2\frac{1}{8}$
inches. Indian ink wash.

xiii. Madame Cibot (Cousin Pons). $4 \times 2\frac{7}{8}$ inches.
Indian ink wash.

xiv. (Jack) Attendons! $3\frac{5}{8}$ inches high, irregular sil-
houette. Dark sepia wash.

xv. Jeanne D'Arc, the childhood of. $9 \times 3\frac{3}{8}$ inches.
Sepia and madder wash on toned paper. First
published in "Second Book," again in "Later
Work."

xvi. Frontispiece to Balzac's "Contes Drôlatiques."
$6\frac{3}{4} \times 4\frac{1}{8}$ inches. Drawn after the manner of

Richard Doyle. First published in "Second Book," again in "Later Work."

xvii. Phèdre (Act ii. scene 5). $3\frac{7}{8} \times 3\frac{1}{2}$ inches. Pencil and colours. First published in "Second Book," again in "Later Work."

xviii. Manon Lescaut, three-quarter length, woman to left, with fan. $5\frac{1}{4} \times 3\frac{1}{2}$ inches. Water-colour on grey paper. First published in "Second Book," again in "Later Work."

xix. Beatrice Cenci. $6\frac{1}{8} \times 2\frac{3}{4}$ inches. Pencil and sepia wash. First published in "Second Book," again in "Later Work."

Unless otherwise stated as above, the works in this collection are unpublished; all were executed 1889-90.

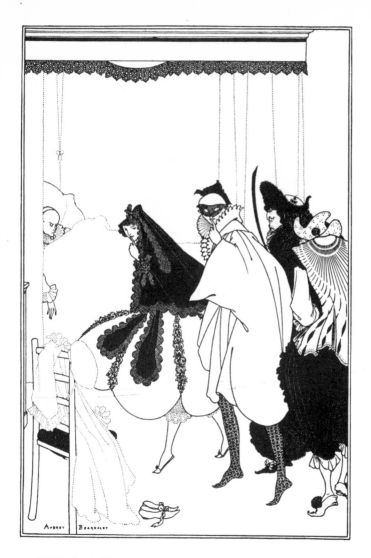

SAVOY: Death of Pierrot.

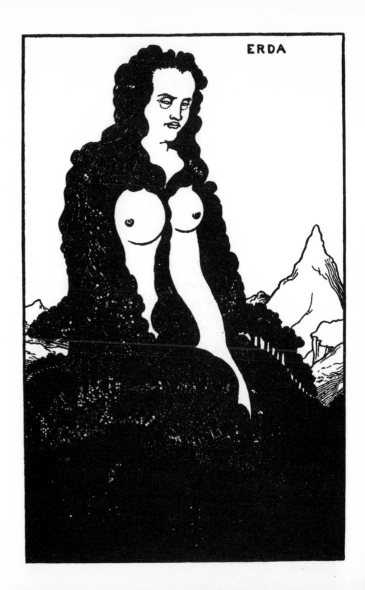

ERDA

SAVOY: Erda of "Das Rheingold"

LATER WORK.

14. FRANCESCA DI RIMINI (Dante). Head in profile, to left; pencil. First published in "Later Work."

15. DANTE AT THE COURT OF CAN GRANDE DELLA SCALA. Circular design, in pencil. (Property of Miss H. Glover.)

16. DANTE IN EXILE. Dante seated on the left, the words of the Sonnet inscribed on the right, with decorations recalling some design of William Blake's. Signed A.V.B. First published in "Later Work." (Formerly the property of the late Hampden Gurney, Esq.)

17. "I SAW THREE SHIPS COME SAILING BY ON CHRISTMAS DAY IN THE MORNING." Pencil. Designed as a Christmas card for the late Rev. Alfred Gurney. Published in "Later Work." *c.* 1890-1.

18. HAIL MARY. Profile of a head to left. Pencil drawing, $4\frac{1}{2} \times 5\frac{1}{4}$ inches. First published in *The Studio*, May 1898, again in "Early Work." (Property of Frederick H. Evans, Esq.) 1891.

19. HEAD, three-quarter face to right, with a Wreath of Grapes and Vine Leaves and background of tree trunks. Lead-pencil sketch $5\frac{1}{2} \times 5\frac{5}{8}$ inches. Unpublished. (Property of John Lane, Esq.) *circa* 1891.

20. THEL GATHERING THE LILY. Pen-and-ink with water-colour wash. (Formerly the property of Robert Ross, Esq.)

21. Two FIGURES IN A GARRET, both seated, a woman haranguing a young man. Ink and wash sketch, $3\frac{1}{4} \times 4\frac{1}{8}$ inches. Published in "Early Work." (Property of Frederick H. Evans, Esq.)

22. E. BURNE-JONES. Portrait sketch in pen-and-ink, with slight wash. A memorandum of Aubrey Beardsley's first call on Sir Edward Burne-Jones, dated Sunday, 12th July 1891, and signed with monogram, A.V.B. Size, $6\frac{3}{4} \times 4\frac{1}{8}$ inches. Eight copies only. Printed on India paper. Published by James Tregaskis, Caxton Head, High Holborn, in 1899. July 1891.

23. THE WITCH OF ATLAS. Pen-and-ink and water-colour wash. First reproduced (lacking ornamental border) in "Second Book," again in "Later Work." (Formerly the property of Robert Ross, Esq.)

24. MOLIÈRE. Blue water-colour wash. First published in "Later Work." (Formerly the property of Robert Ross, Esq.)

25. DIE GÖTTERDÄMMERUNG. Decorative composition in white and Indian ink, influenced by Burne-Jones. First published in "Second Book," again in "Later Work." (Formerly the property of Robert Ross, Esq.)

26. SOLEIL COUCHANT. Decorative composition in Indian ink. (The motif of the central part was subsequently adapted for a vignette in the "Morte Darthur," Book II. chap. xii.) First published in "Later Work." (Formerly the property of the late Hampden Gurney, Esq.)

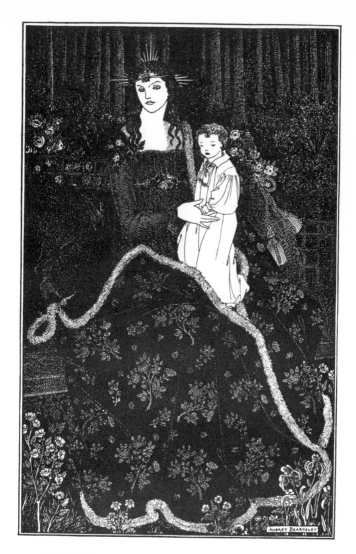

SAVOY: A Christmas Card.

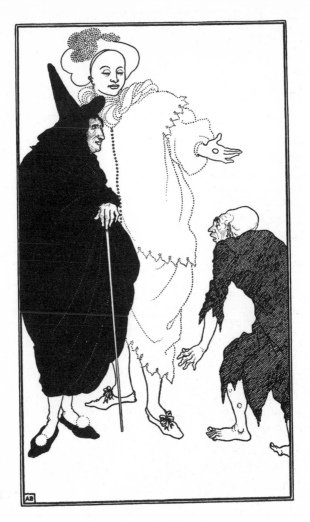

SAVOY: Don Juan, Sganarelle and Beggar.

27. TANNHÄUSER. Study for decorative composition, in Indian ink. $5\frac{5}{8} \times 7\frac{1}{2}$ inches. First published in "Later Work." (Property of Dr Rowland Thurnam.) 1891.

28. WITHERED SPRING. Decorative composition in Indian ink. Catalogued in "Fifty Drawings" as "Lament of the Dying Year." (The motif of the central part was subsequently adapted for a vignette in the "Morte Darthur," Book I. chap. xii.) First published in "Later Work." (Property of Dr Rowland Thurnam.)

29. I. PERSEUS. Pen-and-ink and light wash. Design for an upright panel, with standing nude figure, above it a frieze of smaller figures. $18 \times 6\frac{3}{4}$ inches. First published in "Early Work." (Property of Frederick H. Evans, Esq.)

 II. A pencil sketch of two figures, unfinished, on the reverse of the preceding. Published in "Early Work."

30. L'ABBÉ MOURET. Decorative design for frontispiece of Zola's "La Faute de l'Abbé Mouret." Ink and wash. First published in "Under the Hill." John Lane. 1904. (Property of John Lane, Esq.)

31. HAMLET PATRIS MANEM SEQUITUR. Pencil drawing. Printed in red, as frontispiece to *The Bee*, the Magazine of the Blackburn Technical School, November 1891; reprinted, in black, in "Second Book," again in "Early Work." Latter part 1891.

32. PERSEUS AND THE MONSTRE. Pencil design, $5\frac{1}{2} \times 7\frac{1}{2}$ inches. First appeared in illustration of an article

entitled, "The Invention of Aubrey Beardsley," by Aymer Vallance, in *The Magazine of Art*, May 1898; again in "Early Work." (Property of Aymer Vallance, Esq.) 1891.

33. THE PROCESSION OF JEANNE D'ARC. Pencil outline, treatment inspired by Mantegna, 19½ long by 6½ inches high. First published in *Magazine of Art*, May 1898; again as double page in "Second Book"; again, reduced, in collotype, in "Early Work." (Property of Frederick H. Evans, Esq.) 1891-2.

A pen-and-ink version of the Procession, 30 inches long by 7 high, was made subsequently, about the Spring of 1892, for Robert Ross, Esq. Published in *The Studio*; see below.

34. THE LITANY OF MARY MAGDALEN. Pencil drawing. First published in "Second Book," again in "Later Work." (Formerly Property of More Adey, Esq.) 1892.

35. THE VIRGIN AND LILY. Madonna standing in front of a Renaissance niche and surrounded by Saints, among them St John Baptist kneeling. Pencil outline. Reproduced in photogravure in "Later Work." (Formerly the property of the late Rev. Alfred Gurney, afterwards in the possession of his son, the late Hampden Gurney, Esq.)

36. CHILDREN DECORATING A TERMINAL GOD. Pen-and-ink. (Formerly the property of M. Puvis de Chavannes.)

37. FRED BROWN, N.E.A.C. Pen-and-ink sketch of the art-master in studio. Signed with monogram A.V.B.

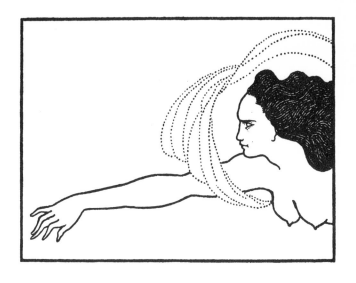

SAVOY: Flosshilde of "Das Rheingold".

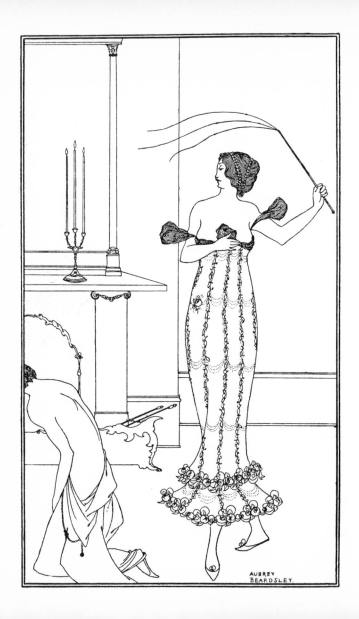

AUBREY
BEARDSLEY.

First published in "Under the Hill." (Property of Miss Nellie Syrett.)

38. STUDY OF FIGURES, horizontal fragment from, containing five heads and parts of two more. Pencil. Published in "Under the Hill." (Property of Miss Nellie Syrett.)

39. PORTRAIT OF THE ARTIST. Full face. Pen-and-ink. First published in "Second Book," again in "Later Work." (Presented by Robert Ross, Esq., to the British Museum.)

40. SIDONIA THE SORCERESS. A design to illustrate Meinhold's Romance, representing Sidonia, not in religious habit, with the demon-cat, Chim. William Morris's criticism that the face of Sidonia was not pretty enough, and another suggested improvement on the part of a friend of Aubrey Beardsley's, induced him to try to better the picture by altering the hair. The result was so far from satisfactory that it is almost certain that the drawing was destroyed by the artist. First half of 1892.

41. LE DÉBRIS D'UN POETE. Pen-and-ink. First published in "Aubrey Beardsley," by Arthur Symons (Sign of the Unicorn, London, 1898). (Property of André Raffalovich, Esq.)

42. INCIPIT VITA NOVA. Chinese, white, and Indian ink on brown paper. First published in "Second Book," again in "Later Work." (Property of Messrs Carfax & Co.) 1892.

43. HEAD OF AN ANGEL, in profile, to left, flaming heart held in left hand. Pencil, on a half-sheet of grey notepaper,

signed with monogram A.V.B. $5\frac{3}{4} \times 3\frac{7}{8}$ inches. First published in photogravure "Second Book," again in "Later Work"; also printed in 4-inch square form on card for private distribution, Christmas 1905. (Property of the artist's sister, Mrs George Bealby Wright [Miss Mabel Beardsley].) *c.* 1892.

44. ADORAMUS TE. Four angels in a circle (7 inches in diameter) playing musical instruments, pencil and coloured chalks. Signed A.V.B. monogram. Designed as a Christmas card for the late Rev. Alfred Gurney. First published in photogravure in "Second Book," again in "Later Work." (Property of Mrs George Bealby Wright.)

45. A CHRISTMAS CAROL. Two angels, one of them playing a hand-organ, in a circle ($7\frac{3}{4}$ inches diameter), pencil and coloured chalks. Designed as a Christmas card for the late Rev. Alfred Gurney. First published in photogravure in "Second Book," again in "Later Work." Also in photogravure, 3 inches diameter, for private circulation. (Property of Mrs George Bealby Wright.) Christmas, 1892.

46 LA FEMME INCOMPRISE. Pen-and-ink and wash. First published in the spring number of *To-Day,* 1895; again in the *Idler* magazine, March 1897.

47. SANDRO BOTTICELLI, three-quarter face to left, pencil, signed with monogram A.V.B.; $14 \times 7\frac{3}{4}$ inches; a reconstruction of the Florentine painter's physiognomy from his extant works, to illustrate Aubrey Beardsley's theory that every artist tends to reproduce his own physical type. Presented by the artist to Aymer

Vallance, Esq. First published in the *Magazine of Art*, May 1898; afterwards in "Early Work." *c.* 1892-3.

48. RAPHAEL SANZIO. Full-length figure, three-quarter face to left, a decorative panel in pen-and-ink, $10\frac{3}{4} \times 3\frac{7}{8}$ inches, exclusive of border lines. Unpublished. (Property of Messrs Obach & Co.)

49. CEPHALUS AND PROCRIS. Pen-and-ink.

50. SMALL BOOKMARKER, woman undressing, a Turkish table in the foreground. Pen-and-ink. First published in "Second Book," again in "Later Work." (Property of Sir William Geary, Bart.) 1893.

51. HERMAPHRODITUS, seated figure, pencil and pale colour tints. Reproduced in colour in "Later Work." (Property of Julian Sampson, Esq.)

52. L'APRÈS-MIDI D'UN FAUNE, par Mallarmé; four designs extra-illustrating a copy of. One of them, a pen-and-ink vignette of a faun, full face, signed with monogram A.V.B., was published in "Second Book." The others unpublished. 1893.

53. DECORATIVE SKETCH DESIGN OF A SAILING SHIP. $1\frac{7}{8} \times 2\frac{1}{2}$ inches. Pen-and-ink on white from the back of a letter to Aymer Vallance, Esq. First published in *Magazine of Art*, May 1898; again in "Early Work." *c.* 1893.

54. ANGEL PLAYING HAND-ORGAN. Pen-and-ink and slight wash, on pale grey notepaper, from a letter to Aymer Vallance, Esq. First published in *Magazine of Art*, May 1898; again in "Early Work." *c.* 1893.

55. THE PALL MALL BUDGET, 1893 and 1894.

 I. MR H. A. JONES AND HIS BAUBLE; pen-and-ink. Feb. 2, 1893, p. 150.

 II. THE NEW COINAGE. Four designs that were not sent in for competition, p. 154. Another design, embodying a caricature of Queen Victoria, was suppressed.

 III. "BECKET" AT THE LYCEUM.

 1. Mr Irving as Becket; wash drawing. Feb. 9th, front page.

 2. Master Leo, p. 188.

 3. Queen Eleanor, p. 188.

 4. Margery, p. 188.

 5. The King makes a Move on the Board, p. 188.

 6. Miss Terry (as Rosamond), p. 188.

 7. Mr Gordon Craig, p. 190.

 8. The Composer, p. 190.

 IV. 1. THE DISAPPOINTMENT OF EMILE ZOLA, p. 202.

 2. EMILE ZOLA; a portrait, p. 204.

 (Republished in "Pall Mall Pictures of the Year," 1893, and in *The Studio*, June 1893.)

 V. VERDI'S "FALSTAFF," AT MILAN, Feb. 16th. Initial letter V; pen-and-ink, p. 236. Portrait of Verdi; ink and wash, p. 236.

 VI. POPE LEO XIII.'s JUBILEE, Feb. 23rd. The Pilgrim (old style), p. 270. The Pilgrim (new style), p. 270.

 VII. THE REAPPEARANCE OF MRS BANCROFT.

 1. Mr Arthur Cecil (Baron Stein), p. 281.

 2. Mrs Bancroft (Lady Fairfax), p. 281.

 3. Mr Forbes Robertson (Julian Beauclere), p. 281.

 4. Mr Bancroft (Count Orloff), p. 281.

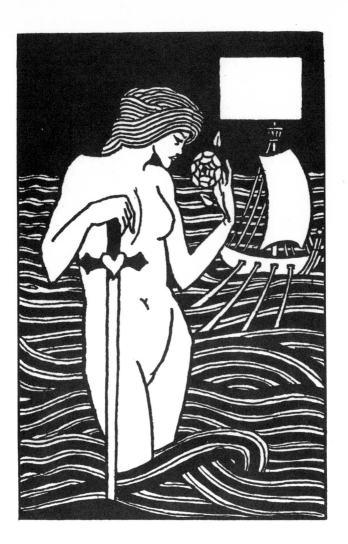

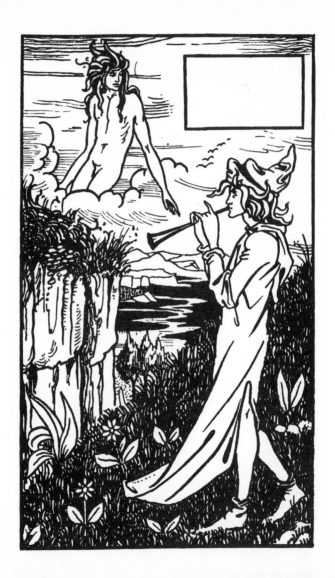

VIII. CARICATURE OF A GOLF PLAYER, in classical helmet, March 9th, p. 376.

IX. ORPHEUS AT THE LYCEUM, March 16th.

 1. One of the Spirits, Act II., p. 395.

 2. Orpheus (Miss Clara Butt), p. 395.

 3. A Visitor at the Rehearsal, p. 395.

 4. Some Dresses in the Chorus, p. 395.

X. PORTRAIT OF THE LATE JULES FERRY: wash drawing, March 23rd, p. 435.

XI. BULLET-PROOF UNIFORM: Tommy Atkins thinks it rather fun, March 30, p. 491.

XII. MR FREDERICK HARRISON's "IDEAL NOVELIST," April 20, p. 620.

XIII. A NEW YEAR'S DREAM, after studying Mr Pennell's "Devils of Notre Dame." Republished in "Early Work." Jan. 4th, 1894, p. 8.

56. MR PARNELL, sketch portrait of the Irish party leader, head and shoulders, three quarters face to left, pencil, half tone reproduction, $4\frac{3}{4} \times 3\frac{1}{2}$ inches.

57. 1. THE STUDIO. Design for wrapper in two states, the original design containing a seated figure of Pan, omitted in the later version. First state on brown paper. The same, reduced, in black on green, for prospectus, republished in *The Studio*, May 1898, and again in "Early Work."

Second state, black on green, also in gold on rough white paper for presentation to Royalty (Nov. 15th, 1893). The same, reduced, and printed in dark green on white, for a prospectus, republished in "Early Work." The same, enlarged and printed in black on light green, for a poster.

Aubrey Beardsley

THE STUDIO, No. 1, April 1893, accompanying an article entitled "A New Illustrator: Aubrey Beardsley," by Joseph Pennell, contained :—

II. Reduced reproduction of the pen-and-ink replica of Jeanne d'Arc procession. Republished as large folding supplement in No. 2.

III. Siegfried, Act II., from the original drawing in line and wash, signed A.V.B., presented by the artist to Sir Edward Burne-Jones, after whose death it was given back by Lady Burne-Jones, to the artist's mother, Mrs Beardsley. Republished in "Early Work."

IV. The Birthday of Madame Cigale, line and wash, 15 inches long by 9½ inches high, influenced by Japanese models. Reproduced in "Early Work." (Property of Charles Holme, Esq.)

V. Les Revenants de Musique, line and wash. Reproduced in "Early Work." (Property of Charles Holme, Esq.)

VI. Salome with the head of St John the Baptist. Upright panel in Chinese ink on white, 10⅛ by 5⅛ inches, exclusive of framing lines. This was the first design suggested to the artist by Oscar Wilde's French play of "Salome." It differs from the later version of the same subject in being richer and more complex. It contains the legend, omitted in the later version, *j'ai baisé ta bouche Iokanaan, j'ai baisé ta bouche.* The treatment is obviously influenced by Japanese work, and also by that of the French Symboliste school, *e.g.* Carlos Schwabe. Republished in "Early Work." Subsequently to its appearance in *The*

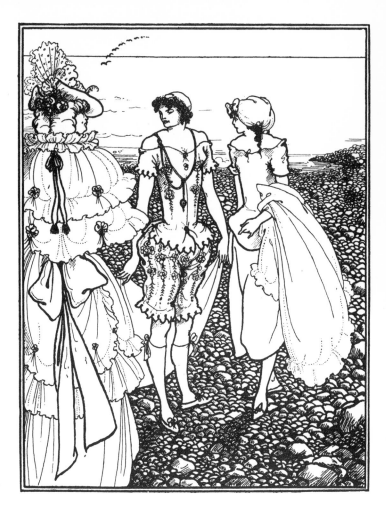

SAVOY: On Dieppe Beach.

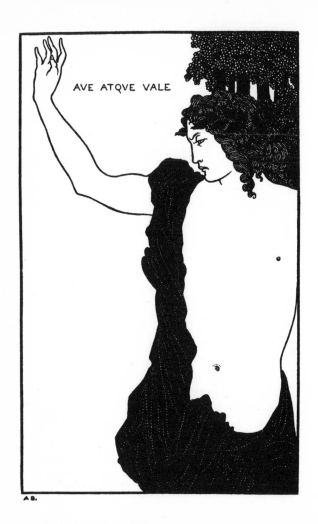

SAVOY: Ave Atque Vale.

Studio, the artist experimentally tinted it with green colour washes. In its final state it has not been published. (Formerly the property of Mrs Ernest Leverson, now of Miss K. Doulton.)

VII. Reduced reproduction of the second version of the Jeanne d'Arc procession. The same appeared, full size, as a folding plate supplement, in No. 2 of *The Studio*, May 1893.

In the first number of *The Studio* (April) also were published, by anticipation, four designs from the "Morte Darthur," due to begin its serial appearance in the following June, viz. :—

VIII. Initial letter I.

IX. Merlin taketh the child Arthur into his keeping (full page, including border).

X. Ornamental border for full page.

XI. Frieze for chapter-heading; six men fighting, on foot, three of them panoplied. Reproduced in *Magazine of Art*, November 1896, "Fifty Drawings," *Idler*, March 1897, and *St Paul's*, April 9th, 1898. The original drawing is $13\frac{3}{4}$ inches long by $4\frac{1}{2}$ inches. As may be seen, even in the reduced reproduction, one inch at either end was added by the artist at the request of his publisher, so as to increase the proportionate length of the ornament. Subsequently Mr Frederick H. Evans photographed the drawing, full size, and produced fifteen platinotype copies, of which twelve only were for sale, and the plate destroyed.

58. DESIGN OF DANDELIONS, for publishers' trade mark for Dent & Co.

59. LE MORTE DARTHUR, by Sir Thomas Malory. J. M.
Dent & Co. 300 copies on Dutch hand-made paper
and 1500 ordinary copies. Issued in Parts, beginning
June 1893.

 I. Vol. I., 1893. Frontispiece—"How King
Arthur saw the Questing Beast, and thereof
had great marvel." Photogravure.
Full-page illustrations :—

 II. Merlin taketh the child Arthur into his keeping.
(Reduced reproduction in *Idler*, May 1898.)

 III. The Lady of the Lake telleth Arthur of the
sword Excalibur.

 IV. Merlin and Nimue.

 V. Arthur and the strange mantle.

 VI. How four queens found Launcelot sleeping.
(Property of A. E. Gallatin, Esq.)

 VII. Sir Launcelot and the witch Hellawes. (Property
of A. E. Gallatin, Esq.)

 VIII. How la Beale Isoud nursed Sir Tristram.

 IX. How Sir Tristram drank the love drink.

 X. How la Beale Isoud wrote to Sir Tristram.

 XI. How King Mark found Sir Tristram sleeping.

 XII. How Morgan le Fay gave a sword to Sir
Tristram.

 XIII. Vol. II., 1894. Frontispiece—"The achieving of
the Sangreal." Photogravure. (This was the
first design executed for the work.)
Full page and double page illustrations :—

 XIV. How King Mark and Sir Dinadan heard Sir
Palomides making great sorrow and mourning
for la Beale Isoud (double page).

 XV. La Beale Isoud at Joyous Gard (double page).

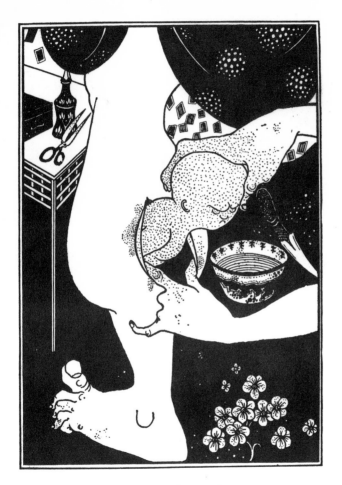

Birth for Lucian's Strange History, Suppressed.

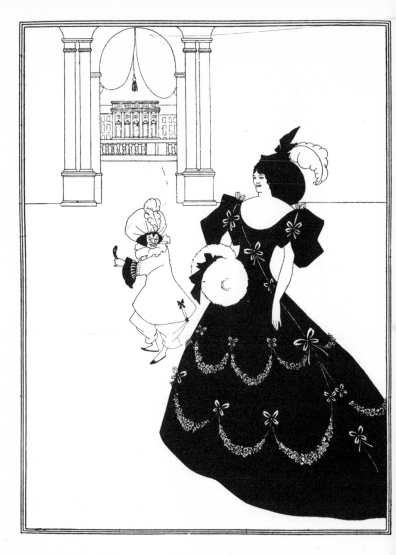

The YELLOW BOOK: Comedy-Ballet of Marionettes I.

XVI. How Sir Launcelot was known by Dame Elaine (full page).

XVII. How a devil in woman's likeness would have tempted Sir Bors (double page).

XVIII. How Queen Guenever rode on maying (double page).

XIX. How Sir Bedivere cast the sword Excalibur into the water (full page).

XX. How Queen Guenever made her a nun (full page). In the two volumes there are altogether 548 ornaments, chapter-headings, borders, initials, tail-pieces, etc.; but some of them are repetitions of the same design, others reproductions of the same design in two different sizes (Two of these are in the Victoria and Albert Museum. Eight belong to Pickford Waller, Esq. Others are the property of Hon. Gerald Ponsonby, R. C. Greenleaf, Esq., W. H. Jessop, Esq., M. H. Sands, Esq., Robert Ross, Esq., and Messrs Carfax & Co.)

XXI. Chapter-heading, a dragon, with conventional foliage spray branching into marginal ornaments; printed, but not published in the book.

XXII. Initial letter J with guardian griffins; pen-and-ink, $5\frac{1}{2} \times 3\frac{1}{2}$ inches.

XXIII. Unfinished border design, first published in "Whistler's Art Dicta and Other Essays" by A. E. Gallatin (Boston, U.S.A., and London, 1903). (Property of A. E. Gallatin, Esq.)

XXIV. Original study, approved by the publisher, for wrappers of serial issue of the "Morte Darthur," yellowish green water-colour on

white paper, $10\frac{1}{4} \times 8\frac{1}{4}$ inches. This design, comprising lilies, differs from that which was finally produced by the artist and published (next item). (Property of Aymer Vallance, Esq.) 1893.

Design for wrappers of serial issue, in black on grey paper, in two states, the earlier or trial-state, having blank spaces for the lettering, only the title being given as " La Mort Darthure."

xxv. Design in gold on cream-white cloth cases of the bound volumes.

Nineteen of the above designs were republished in " A Book of Fifty Drawings," and again in " Later Work," including full-size reproductions of the following, which had suffered through excessive reduction in the published " Morte Darthur."

xxvi. Merlin (in a circle), facing list of illustrations in Vol. I. The same reproduced in *The Idler*, March 1897.

xxvii. Vignette of Book I., chapter xiv. Landscape with piper in a meadow and another figure in the sky.

xxviii. Vignette of Book III., chapter iii. Three swans swimming.

xxix. Vignette of Book V., chapter x. Nude woman rising out of the sea, holding in one hand a sword, in the other a rose.

60. PALL MALL MAGAZINE, JUNE 1893.

1. Of a Neophyte, and how the Black Art was revealed unto him by the Fiend Asomuel. Full-

THE YELLOW BOOK

AN ILLVSTRATED QVARTERLY.

BOOKS D...

PRICE
FIVE SHILLINGS

ELKIN MATHEWS
AND JOHN LANE,
THE BODLEY HEAD
VIGO ST. LONDON.

APRIL 15ᵗ
MDCCC XCIV.

The YELLOW BOOK: Prospectus.

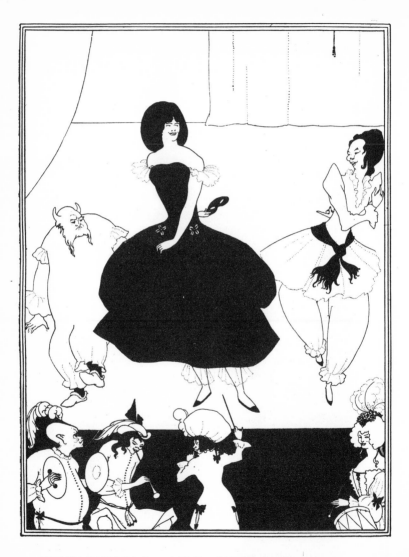

The YELLOW BOOK: Comedy-Ballet of Marionettes III.

page illustration in pen and ink. Asomuel, meaning insomnia, was a neologism of the artist's own devising, made up of the Greek *alpha* privative, the Latin *somnus,* and the Hebrew *el,* for termination analogous to that of other spirits' names, such as Gabriel, Raphael, Azrael, etc., reproduced in "Early Work," July 1893.

II. The Kiss of Judas. Full-page illustration in pen-and-ink. Reproduced in "Early Work."

61. LA COMÉDIE AUX ENFERS, pen and ink, published in "Modern Illustration," by Joseph Pennell. (G. Bell & Sons, 1895.) Imp. 16mo. 1893.

62. I. EVELINA, by Frances Burney. (Dent & Co., 1894.) Design in outline for title-page.

II. EVELINA AND HER GUARDIAN, design for illustration, pen and ink and wash, $6\frac{7}{8} \times 4\frac{7}{8}$ (exclusive of marginal lines), not published.

III. Another illustration for the same, "Love for Love," a wash drawing, $7\frac{1}{2} \times 5\frac{1}{4}$, unpublished. 1893.

63. VIRGILIUS THE SORCERER. David Nutt, 1893. Frontispiece to the large paper copies only. Reproduced in "Early Work."

64. THE LANDSLIP, frontispiece to "Pastor Sang," being William Wilson's translation of Björnson's drama, "Over Ævne." Longmans & Co., 1893. A black and white design, in conscious imitation of Albert Dürer, as the peculiar form of the signature A. B. shows, the only occasion on which the artist employed this device. Reproduced in "Early Work." (Property of Messrs Shirley & Co., Paris.)

65. BON MOTS. 3 VOLUMES. DENT & CO., 1893.
 I. Title-page reproduced in " Later Work."
 II. Figure with fool's bauble, and another small orna-
 ment for the cover.
 III. 208 grotesques and other ornaments in the three
 volumes. Some of these, however, are repeated,
 and some printed in different sizes. Three of
 them reproduced in " Later Work." In an
 article by Max Beerbohm in the *Idler*, May
 1898, accompanied by " some drawings that
 have never before been reproduced," are nine
 small vignettes of the " Bon Mots " type, of
 which number three only are explicitly ascribed
 to " Bon Mots." (A sheet of them belongs
 to W. H. Jessop, Esq. Nineteen are the
 property of Pickford Waller, Esq.)

66. FOLLY, intended for "Bon Mots," but not used in the
 book. The figure is walking along a branch of haw-
 thorn, the left hand upraised, and holding the fool's
 baton; a flight of butterflies in lower left-hand corner;
 with drawing $8 \times 5\frac{1}{4}$ inches. (Property of Littleton
 Hay, Esq.)

67. PAGAN PAPERS, a volume of Essays by Kenneth Grahame.
 Elkin Mathews and John Lane, 1893. Title-page,
 design for.

68. ADA LUNDBERG, head and shoulders to right, coloured
 crayons on brown paper. Reproduced in colour in
 " Later Work." (Property of Julian Sampson, Esq.)

69. KEYNOTES SERIES OF NOVELS AND SHORT STORIES.—
 (The publication of this series was begun by Messrs

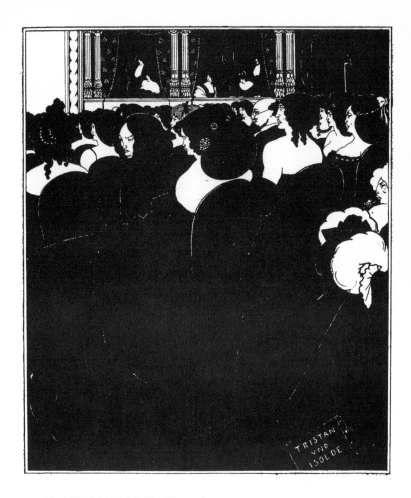

The YELLOW BOOK: The Wagnerites.

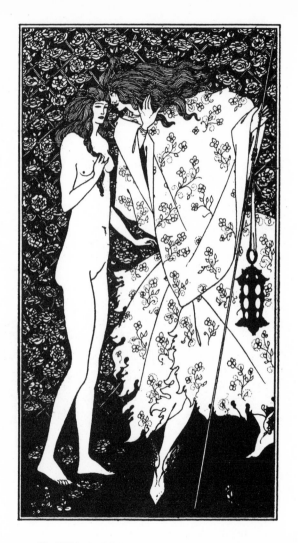

The YELLOW BOOK: The Mysterious Rose Garden.

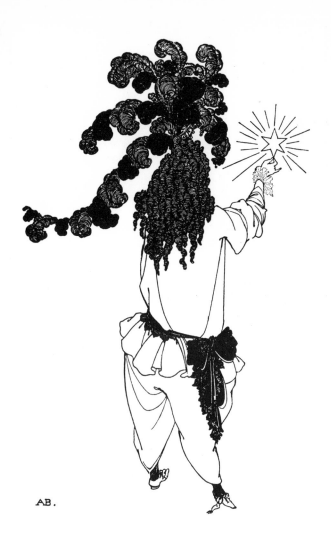

AB.

The New Star.

LES LIAISONS DANGEREUSES.

BY
CHODERLOS
DE LACLOS

AB

SAVOY: Count Valmont.

Elkin Mathews and John Lane, and afterwards continued by Mr John Lane alone.)

I. Keynotes by George Egerton, 1893. Title-page design (the same employed for the cloth cover). Ornamental key, embodying the author's monogram, on back of "Contents" page (the same device on the back of the book). This plan was adopted for each volume of the series.

II. The Dancing Faun, by Florence Farr (the Faun in the design has the eyeglass and features of J. McNeill Whistler).

III. Poor Folk. Translated from the Russian of F. Dostoievsky, by Lena Milman.

IV. A Child of the Age, by Francis Adams.

V. The Great God Pan and the Inmost Light, by Arthur Machen, also unfinished sketch in pencil upon the back of the finished design.

VI. Discords, by George Egerton.

VII. Prince Zaleski, by M. P. Shiel.

VIII. The Woman who Did, by Grant Allen.

IX. Women's Tragedies, by H. D. Lowry, 1895.

X. Grey Roses, by Henry Harland.

XI. At the First Corner, and other Stories, by H. B. Marriott Watson.

XII. Monochromes, by Ella D'Arcy.

XIII. At the Relton Arms, by Evelyn Sharp.

XIV. The Girl from the Farm, by Gertrude Dix.

XV. The Mirror of Music, by Stanley V. Makower.

XVI. Yellow and White, by W. Carlton Dawe.

XVII. The Mountain Lovers, by Fiona Macleod.

XVIII. The Woman who Didn't, by Victoria Crosse.

XIX. Nobody's Fault, by Netta Syrett.

xx. The Three Impostors, by Arthur Machen.

xxi. The British Barbarians, a hill-top novel, by Grant Allen.

xxii. Platonic Affections, by John Smith.

Design for wrapper of " Keynotes " series. John Lane, 1896.

(With the exception of No. 2 all the above Keynotes designs are the property of John Lane, Esq.)

70. The Barbarous Britishers, a tip-top novel, by H. D. Traill. Title-page design (the same employed for the cloth cover), comprising a portrait of Miss Ada Lundberg, the whole being a parody of the design for " The British Barbarians," *vide supra.* John Lane, 1896. (Property of John Lane, Esq.) Reproduced in " Early Work."

71. Three Headpieces, two of which appeared in *St Paul's,* April 2nd, 1898, the other in the same paper, April 9th, 1898. All three republished in " Early Work." (Property of Henry Reichardt, Esq.) 1893-4.

72. Women regarding a Dead Mouse. Three-quarter figure in leaden grey. Unfinished painting in oils, the only experiment the artist ever made in this medium ; influenced by Walter Sickert. *c.* 1894.

73. Menu of the Tenth Annual Dinner of the Playgoers' Club in London. Two drawings, one of them only reproduced in " Early Work." January 28th, 1894.

74. Lucian's True History. Laurence & Bullen, privately printed, 1894. Black and white illustrations to

1. A Snare of Vintage. Reproduced in " Later Work."

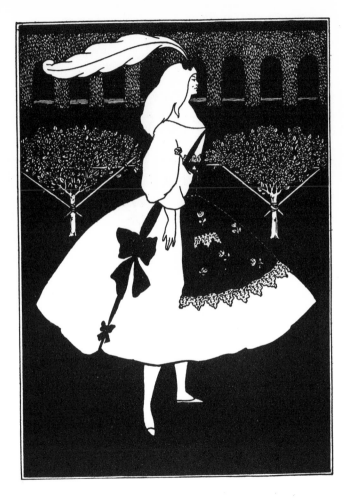

The YELLOW BOOK: The Slippers of Cinderella.

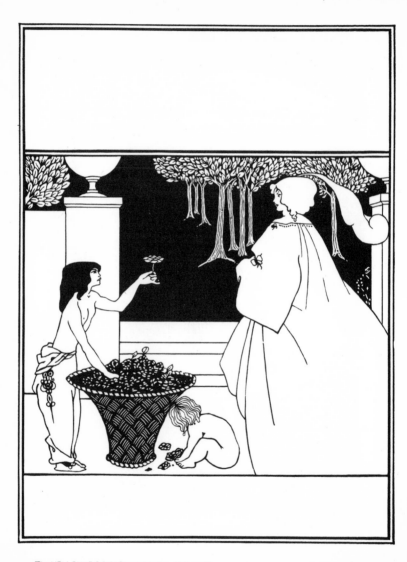

The YELLOW BOOK: Cover Design, Volume V.

Another drawing of the same subject and title, but different rendering, 6 × 4½ inches, was inserted loose in large paper copies only ; not noted in "Contents" page of the book.

 II. Dreams. Reproduced in "Later Work." This drawing was executed obviously at the same period as "Siegfried" and "The Achieving of the Sangreal."

III., IV. Two more drawings, intended for the same work, but not included in it. Twenty copies of each were printed privately. One of them is unpublished ; of the other, the upper portion was published in "Later Work." These illustrations were the earliest of the Artist's designs not intended for public circulation.

LUCIAN'S TRUE HISTORY, translated by Francis Hickes, illustrated by William Strang, J. B. Clark, and Aubrey Beardsley, with an Introduction by Charles Whibley, was published by A. H. Bullen. London, 1902.

75. QUILP'S BARON VERDIGRIS. Black and white. Designed for Messrs Henry & Co. First published in "Second Book" and again in "Later Work." 1894.

76. POSTER FOR "THE COMEDY OF SIGHS," by Dr John Todhunter, at the Avenue Theatre, March 29th, 1894. Three-quarter length figure of woman in deep blue, standing behind a gauze curtain with light green round spots powdered over it, 28¾ × 4¾ inches. The same has since been printed, the original size, in black and white. The same reduced, and printed in blue on light green paper for the programme sold in the theatre :

also printed in black on toned paper for the programme of Mr G. Bernard Shaw's play, "Arms and the Man," April 21st, 1894. Also still further reduced, in black on pale mauve-pink paper for the wrapper of Mr W. B. Yeats's play, "The Land of Hearts' Desire." Reproduced in *Idler* magazine, March 1897; again in "Fifty Drawings," also in "Later Work." This was Aubrey Beardsley's first poster design. 1894.

77. POSTER FOR MR FISHER UNWIN'S "PSEUDONYM LIBRARY." Female figure in salmon-pink dress standing on the opposite side of the road to a second-hand book-store. The scheme of colouring—salmon-pink, orange, green, and black — was suggested to Aubrey Beardsley by a French poster. $29\frac{1}{2} \times 13$ inches.

The same reduced, in colours, to form an advertisement slip for insertion in books and magazines.

The same reduced, printed in black, 6 copies only, on Japanese vellum. Reproduced in "Fifty Drawings" and "Later Work." Also used as cover-design for the "Dream and the Business," by John Oliver Hobbes.

Similar motif, black and white drawing; exhibited at the New English Art Club Exhibition at the New Gallery. (Property of T. Fisher Unwin, Esq.)

78. POSTER FOR MR FISHER UNWIN'S CHILDREN'S BOOKS. Woman reading while seated in a groaning-chair; black and purple. Reproduced in black in "Fifty Drawings" and "Later Work."

79. Poster Design. A lady and large sunflower, scheme of colouring purple and yellow. Unpublished. Pur-

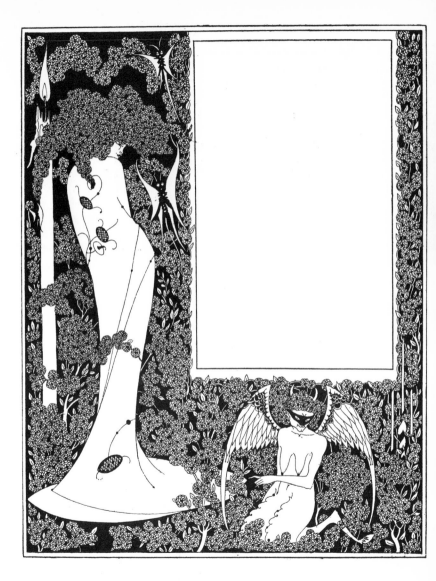

SALOME: Contents Page Design.

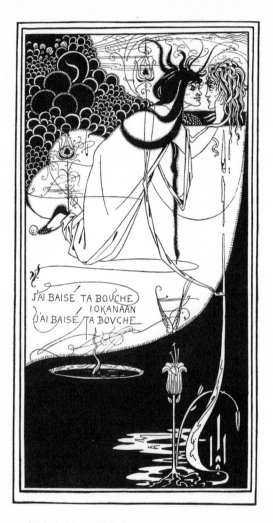

SALOME: Salome with St. John's Head.

chased by Mr Fisher Unwin and destroyed accidentally in New York.

80. SKETCH PORTRAIT OF THE ARTIST, head and shoulders, three-quarter face to left; in imaginary costume with V-shaped opening to his coat and high-shouldered sleeves; in charcoal. First published in *The Sketch*, April 14th, 1894, again in "Early Work."

81. SKETCH PORTRAIT OF HENRY HARLAND, head and shoulders, three-quarter face to right, in charcoal. First published in *The Sketch*, April 11th, 1894, again in "Early Work." (Property of John Lane, Esq.)

82. PORTRAIT OF JAMES M‘NEILL WHISTLER. (Property of Walter Sickert, Esq.)

83. THE FAT WOMAN (a caricature of Mrs Whistler). First published in *To-Day*, May 12th, 1894, afterwards republished in "Fifty Drawings" and "Later Work"; also in *Le Courrier Français*, November 11th, 1894, with the title "*Une Femme bien Nourrie.*" (Formerly the property of the late Mrs Cyril Martineau (Miss K. Savile Clarke)).

84. WAITING, a haggard, expectant woman, wearing V-necked bodice and large black hat, seated in a restaurant, with a half-emptied wine-glass on a small round table before her; black-ink drawing, $7\frac{3}{8} \times 3\frac{1}{2}$ inches, unpublished. (Property of Pickford Waller, Esq.)

85. MASKED PIERROT AND FEMALE FIGURE, water and gondolas in background, small square in black and white, published in *To-Day*, May 12th, 1894.

86. SALOME, A tragedy in one act. Translated by Lord Alfred Douglas from the French of Oscar Wilde. Elkin Mathews and John Lane, 1894. Pictured with the following designs by Aubrey Beardsley :—

 I. The woman (or man) in the moon (Frontispiece).

 Border Design for Title-page (two states, the first cancelled). Property of John Lane, Esq.)

 Border Design for List of Pictures. (Property of John Lane, Esq.)

 II. The Peacock Skirt. (Property of John Lane, Esq.)

 III. The Black Cape. A burlesque, substituted for a drawing of John and Salome, which was printed but withheld, and subsequently published in "Early Work." (Property of John Lane, Esq.)

 IV. A Platonic Lament. (Property of John Lane, Esq.)

 V. Enter Herodias (two states, the first cancelled). (The drawing in its original state the property of Herbert J. Pollit Esq.) A proof of this drawing in its first state, now the property of Frank Harris, Esq., is inscribed by the artist on the left-hand top corner :

> " Because one figure was undressed
> This little drawing was suppressed.
> It was unkind, but never mind,
> Perhaps it all was for the best."

 VI. The Eyes of Herod. (Note one of Herod's white peacocks.) (Property of John Lane, Esq.)

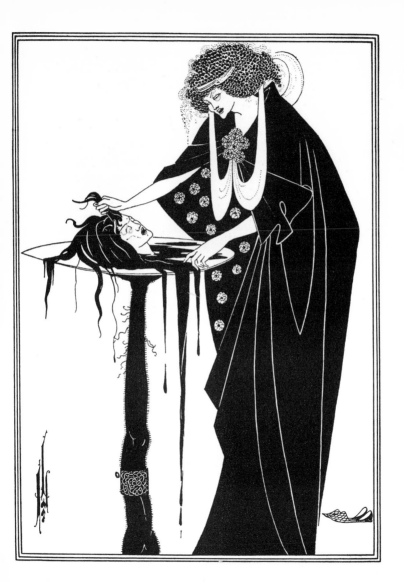

SALOME: The Dancer's Reward.

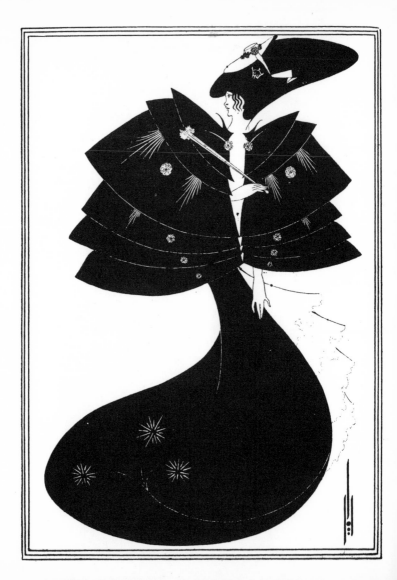

SALOME: The Black Cape.

VII. The Stomach Dance. (The author makes
Salome dance, barefooted, the Dance of the
Seven Veils.) (Property of John Lane, Esq.)

VIII. The Toilette of Salome. Substituted for a
former drawing of the same subject, printed in
two states but withheld, the second state subse-
quently published in " Early Work " (Property
of Robert Ross, Esq.)

IX. The Dancer's Reward. (Property of John Lane,
Esq.)

X. The Climax. This is a revised and simpler
version of the design which had appeared in the
first number of *The Studio.*

Tailpiece. The corpse of Salome being coffined
in a puff-powder box. (Property of John
Lane, Esq.)

Nos. I., IV., V., and VI. of the above contain
caricatures of Oscar Wilde.

XI. Small design, printed in gold on cloth, front cover
of "Salome"; another, consisting of an elabora-
tion of the artist's device, for the under side of
cover.

XII. Study of a design of peacock feathers for cover of
" Salome," not used at the time, but sub-
sequently reproduced for the first time in
facsimile in " Early Work," and again as an
illustration following the title-page in reissue
of " Salome " (John Lane, 1907) ; also in gold
on light green cloth for ornament of the binding,
and in olive green on orange-red for the paper
cap. Also in gold on blue cloth for binding
of " Under the Hill," 1904. (Property of

John Lane, Esq.) This (1907) edition, more-over, contains the two illustrations suppressed in the original edition, viz., " John and Salome " (Property of John Lane, Esq.), now placed in order as No. 8, and " The Toilet of Salome, II.," now placed as No. 13 (Property of John Lane, Esq.) and an original title-page.

XIII. The Salome drawings were reproduced the actual size of the originals and published in a portfolio. In this was included a design of Salome seated upon a settee. Described in " Early Work " as " Maitresse d'Orchestre." (John Lane, 1907.)

87. DANCER WITH DOMINO. (The property of His Honour Judge Evans.)

88. PLAYS, BY JOHN DAVIDSON. Elkin Mathews and John Lane, 1894. Design on frontispiece to, containing portrait caricatures of Sir Augustus Harris, and Oscar Wilde and Henry Harland, black and white ; the same design in gold on the cloth cover. Re-produced in " Early Work," and again, with Aubrey Beardsley's letter to the *Daily Chronicle* on the subject, in " Under the Hill," 1904. (Property of John Lane, Esq.)

Design for Title-Page of the above-named. Black and white ; reproduced in " Early Work."

89. THE YELLOW BOOK, 1894 AND 1895.

1. Design for prospectus of the " Yellow Book " : a woman examining books in a box at a bookstall ; black on yellow paper. Elkin Mathews and John Lane, 1894. (Property of John Lane, Esq.)

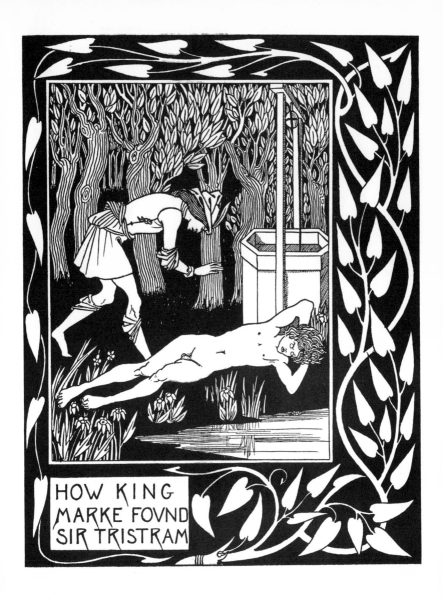

HOW KING
MARKE FOVND
SIR TRISTRAM

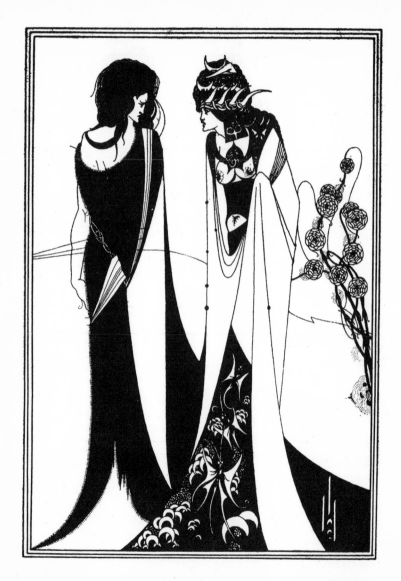

SALOME: John and Salome.

Vol. I., April 1894. Elkin Mathews and John Lane.

II. Design on front side of yellow cover. (Property of John Lane, Esq.)

III. Design on under side of cover; the same repeated in the later volumes. (Property of John Lane, Esq.)

IV. Design on title-page: a woman playing a piano in a meadow. Reproduced, with Aubrey Beardsley's letter on the subject, to the *Pall Mall Budget*, in "Under the Hill" (1904). (Property of John Lane, Esq.)

V. L'Education Sentimentale: in line and wash.

VI. Night Piece.

VII. Portrait of Mrs Patrick Campbell in profile, to left in outline. Formerly in possession of Oscar Wilde, now in National Gallery at Berlin.

VIII. Bookplate (designed in 1893) for John Lumsden Propert, Esq.

Vol. II., July 1894. Elkin Mathews and John Lane.

IX. Design on front side of cover. (Property of John Lane, Esq.)

X. Design on title-page.

XI. The Comedy-Ballet of Marionettes. Three designs.

XII. Garçons de Café. (Property of A. W. King, Esq.)

XIII. The Slippers of Cinderella. The artist subsequently coloured the original with scarlet and green, in which state it is unpublished. (Property of Brandon Thomas, Esq.)

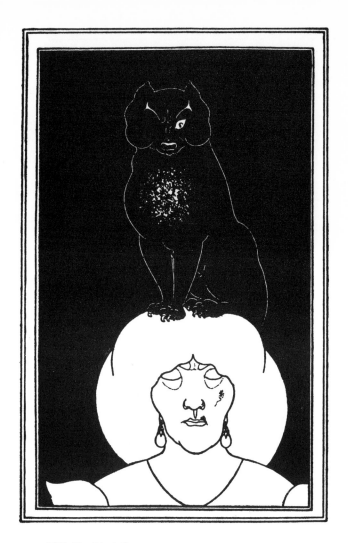

POE: The Black Cat.

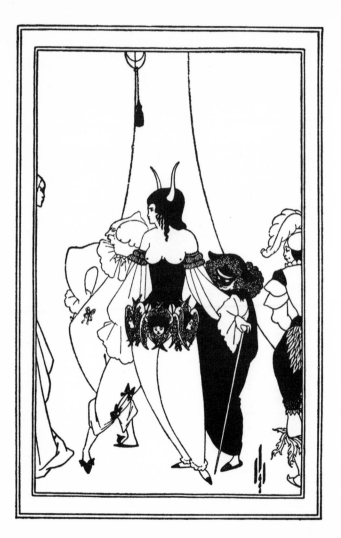

POE: The Mask of Red Death.

xxv. The Mysterious Rose Garden, burlesque Annunciation. (Property of John Lane, Esq.)

xxvi. The Repentance of Mrs ——. (The kneeling figure is a reminiscence of the principal one in "The Litany of Mary Magdalen.")

xxvii. Portrait of Miss Winifred Emery (outline). (Property of Mrs Cyril Maude.)

xxviii. Frontispiece for Juvenal. Double-page supplement.

xxix. Design for "Yellow Book" Cover, not used. First published in "Early Work." (Property of John Lane, Esq.)

xxx. Show-card to advertise "The Yellow Book"; female figure standing, her hat hanging from her right hand, and daffodils growing at her feet. Dark green on light yellow paper. Reproduced in black-and-white in "Early Work." (The property of John Lane, Esq.)

90. PORTRAIT OF RÉJANE wearing a broad-brimmed hat with dark bow in front, head and shoulders, full face slightly to left, wash drawing. Reproduced by Swan Electric Engraving Company for the "Yellow Book," but not used. Unpublished.

91. RÉJANE, black-and-white design of the actress standing, half length, fan in hand, against a white curtain with conspicuous tassel. First published in "Second Book," and again, in a reduced state, as "Title-page ornament, hitherto unpublished" in "Early Work." 1893-4.

92. MADAME RÉJANE, full-length portrait sketch, ink and wash. First published in "Second Book," again in "Later Work."

93. MADAME RÉJANE, profile to left; sitting, legs extended, on a sofa, ink and wash. First published in "Pen Drawing and Pen Draughtsmen," by Joseph Pennell (Macmillan, 1894), again in "Fifty Drawings," and in the *Idler* Magazine, March 1897.

94. RÉJANE, portrait head in profile to left, in red crayon and black ink, $7\frac{1}{2} \times 6$ inches. First published in facsimile in *The Studio*, May 1898, again in "Later Work." (Property of Frederick H. Evans, Esq.) 1894.

95. A POSTER DESIGN. Back view of a woman, her face in profile to right, holding a pigmy in her right hand. First published in "Early Work." (Property of John Lane, Esq.)

96. A POSTER DESIGN (Singer). Woman seated at a piano. First reproduced in *The Poster*, October 1898, again in "Second Book" and in "Later Work."

97. LADY TO RIGHT GAZING AT A HAT ON A MILLINER'S BONNET STAND, headpiece for the "Idlers' Club" section in the *Idler* Magazine, 1894.

98. PIERROT AND BLACK CAT, small square in black-and-white for a book ornament.

99. HEAD AND SHOULDERS OF A CHINESE PRIEST, together with the Head of a Satyr. 25 copies only printed on folio sheet, and 10 copies only in red. It is not known

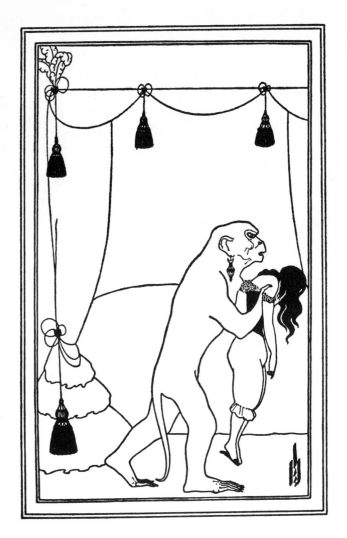

POE: Murder in the Rue Morgue.

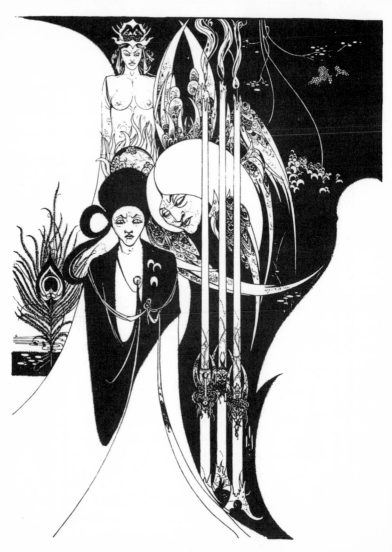

A Neophyte and the Fiend Asomul.

for what they were intended. Published by James Tregaskis, Caxton Head.

100. LES PASSADES, night scene, in pen-and-ink with ink wash, 10×5 inches. First published in *To-Day*, November 17, 1894, again in the *Idler* Magazine, March 1897.

101. VENUS BETWEEN TERMINAL GODS. Frontispiece for a version of the Tannhäuser legend, to be published by Messrs H. Henry & Co. Ltd., a project never completed. Design in black-and-white, showing, especially in the treatment of flying dove and of the background of rose-trellis, the influence of Charles Ricketts or Laurence Housman. Reproduced in " Second Book," and again in " Later Work." *Circa* 1894-5.

102. FRONTISPIECE AND TITLE-PAGE, together forming one complete design, for " The Story of Venus and Tannhäuser," to be published by John Lane, but never completed. (*Cf.* " Under the Hill " in *The Savoy*, 1896.) Reproduced in " Early Work." Dated 1895. (Property of John Lane, Esq.)

103. THE RETURN OF TANNHÄUSER TO VENUSBERG. A design originally intended for the above-named book. Subsequently presented by the artist to J. M. Dent, Esq. First published, in illustration of an article by Max Beerbohm, in the *Idler* Magazine for May 1898, and again, in larger format and, as the initials in left hand corner show, reversed, in " Second Book " and again in " Later Work." The *Idler* version has a slight effect of half-tone in the brambles in the foreground, but the " Later Work " reproduction is pure black-and-white contrast.

104. VENUS. Design for title-page, in black-and-white. First published in *The Studio*, 1898, and afterwards in " Early Work," March 2, 1899, where it is described as " hitherto unpublished." (The property of John Lane, Esq.)

105. DESIGN FOR COVER OF " THE CAMBRIDGE A, B, C." Reproduced in " Early Work."

106. PIERROT AS CADDIE, Golf Club Card, designed for the opening of The Prince's Ladies' Golf Club, Mitcham, pen-and-ink. Published in " Early Work." (Formerly the property of Mrs Falconer-Stuart, now of R. Hippesley Cox, Esq.) Dated 1894.

107. A POSTER DESIGN ; two female figures drawn in black-and-white for Mr William Heinemann. Reproduced in " Early Work."

108. THE LONDON GARLAND, published by the Society of Illustrators, 1895. A pen-and-ink drawing of a female figure in very elaborated dress reaching from her neck to the ground, intended to represent a ballet-dancer with a costume as prescribed by Mrs Grundy. The original drawing, unfinished, contains another figure, not reproduced, on the left. The original title for this drawing was " At a Distance." Reproduced in " Second Book." (Property of Joseph Pennell, Esq.)

109. AUTUMN. Design in black-and-white for a calendar to be published by William Heinemann. Reproduced in " Early Work."

110. TALES OF MYSTERY AND WONDER, by Edgar Allen Poe

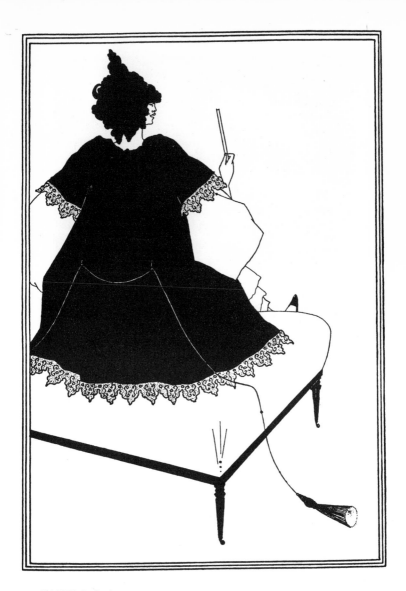

SALOME: On Settle.

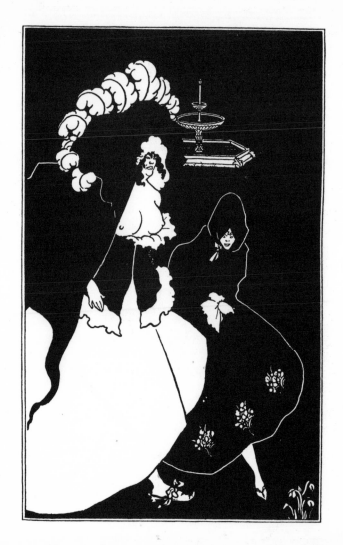

Messalina Going to the Lupanar.

(Stone & Kimball, Chicago, U.S.A., 1895); four designs in pen-and-ink for large paper edition of—

 I. The Murders in the Rue Morgue.

 II. The Black Cat.

 III. The Masque of the Red Death. First published in the " Chap Book " (Chicago), Aug. 15, 1894, again in same, April 1, 1898.

 IV. The Fall of the House of Usher.

111. OUTLINE PORTRAIT OF THE ARTIST in profile to left; in imaginary costume, with a lace ruff to the neck, and earrings in the ears. Published in " Posters in Miniature," and again in " Early Work." A half-tone block from variant of the same, the earring as well as the button on lappel and waist of coat more pronounced, was published in *The Hour*, March 27, 1895, and reproduced in *Magazine of Art*, November 1896.

112. A CHILD STANDING BY ITS MOTHER'S BED, black-and-white, chiefly outline. First published in *The Sketch*, April 10, 1895. Reproduced in " Early Work." Formerly in the possession of Max Beerbohm, Esq., but since lost.

113. THE SCARLET PASTORALE, pen-and-ink. First published in *The Sketch*, April 10, 1895. Also printed in scarlet on white. Reproduced in " Fifty Drawings."

114. PORTRAIT OF MISS ETHEL DEVEREUX, pencil drawing. (Property of Mrs Roy Devereux.) *Circa* 1895.

115. DESIGN FOR AN INVITATION CARD, ink outline; seated Pierrot smoking, a copy of the " Yellow Book," Vol. IV., on the couch at his side. Drawn for Mr John Lane's Sette of Odd Volumes Smoke. Reproduced in *The Studio*, September 1895. (Property of John Lane, Esq.)

116. THREE DECORATIVE DESIGNS from the brown paper cover of Aubrey Beardsley's own copy of "Tristan und Isolde." Two reproduced in "Later Work." (Property of Frederick H. Evans, Esq.)

117. MAX ALVARY AS "TRISTAN" in Wagner's opera "Tristan und Isolde," half-length profile to left, pen-and-ink and wash with unusual monogram signature. $10 \times 5\frac{1}{2}$ inches. First published in "Aubrey Beardsley's Drawings, a catalogue and a list of criticisms," by A. E. Gallatin (New York, 1903). (Formerly the property of Rev. G. H. Palmer, now of A. E. Gallatin, Esq.)

118. FRAU KLAFSKY AS "ISOLDE" in above-named opera, pen-and-ink and pale green water-colour, $13 \times 4\frac{3}{4}$ inches. First published in the *Critic* (New York), December, 1902. (Formerly the property of Rev. G. H. Palmer, now of A. E. Gallatin, Esq.)

119. ISOLDE; autolithograph in scarlet, grey, green, and black on white; supplement to *The Studio*, October 1895.

120. WOMAN RECLINING IN A MEADOW BY THE BORDER OF A LAKE, LISTENING TO A FAUN READING OUT OF A BOOK TO HER. Oblong design in ink on white; a variant of the design for wrapper of Leonard Smithers' Catalogue, No. 3. First published in *The Studio*, May 1898, again in "Early Work," where it is described as "hitherto unpublished." (Property of John Lane, Esq.) 1895.

121. DESIGN FOR WRAPPER OF "CATALOGUE OF RARE BOOKS," No. 3. (Leonard Smithers, September 1895.) The same figures as in the last-named, but the landscape

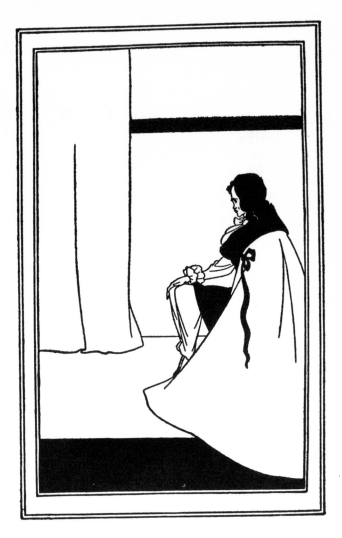

POE: Fall of the House of Usher.

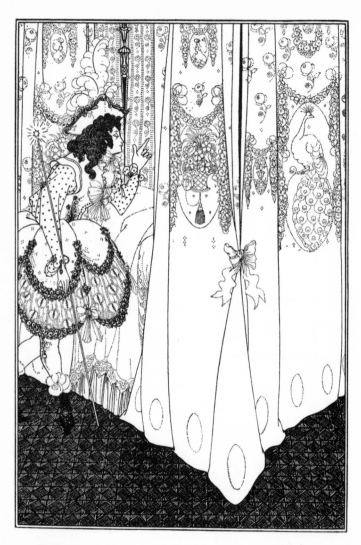

The Dream.

has an urn and additional trees to adapt the design to upright shape. Black on pale blue-green paper.

122. CHOPIN BALLADE III., illustration for. Woman rider, mounted on a prancing white horse to left. Wash drawing. First published in *The Studio*, May 1898, in half tones of grey, with deep purplish black; again in "Second Book." (Property of Charles Holme, Esq.) 1895.

123. CHOPIN'S NOCTURNES, frontispiece to. Pen-and-ink and wash. First published in "Early Work." (Property of John Lane, Esq.)

124. EARL LAVENDER, by John Davidson (Ward & Downey, 1895), design for frontispiece to. Woman scourging a kneeling, barebacked figure. Pen-and-ink outline. Reproduced in "Early Work." (Property of John Lane, Esq.)

125. YOUNG OFEG'S DITTIES, by George Egerton (John Lane, 1895), title-page and cover design for.

126. MESSALINA, with another woman on her left, black-and-white, with black background. First published in "Second Book," again in "Early Work," where it is described as "hitherto unpublished." 1895.

127. TITLE-PAGE ORNAMENT, standing nude figure playing double-bass, black background. First published in "Early Work."

128. PORTRAIT OF MISS LETTY LIND in "The Artist's Model." Pen-and-ink outline. Published in "Early Work." (Property of Miss Letty Lind.)

129. ATALANTA IN CALYDON, full-length figure to right; pen-and-ink and wash. First published in "Early Work." (Property of John Lane, Esq.)

130. COVER DESIGN FOR FAIRY TALES by Count Hamilton, to be published by Messrs H. Henry & Co., Ltd.

131. BALZAC'S "LA COMÉDIE HUMAINE," design (head, full face) for front side and another for the reverse of cover. Reproduced in "Later Work."

132. THE BROOK TRILLS OF PERNICIOUS BY RICHARD LE PHILIS-TIENNE, title-page to burlesque, that of "The Book Bills of Narcissus," by Richard le Gallienne. Unpublished. (Property of J. M. Dent, Esq.)

133. A SELF-PORTRAIT, grotesque outline profile to left, with diminutive silk hat, from the fly-leaf of an envelope in the possession of J. M. Dent, Esq. Unpublished.

134. THE SHAVING OF SHAGPAT, by George Meredith, small sketch to illustrate, in pen-and-ink, contained in a letter to Frederick H. Evans, Esq. Unpublished.

135. AN EVIL MOTHERHOOD, by Walt Ruding (Elkin Mathews, 1896), frontispiece to. Pen-and-ink. Reproduced in "Early Work."

136. CAFÉ NOIR. Another design for the frontispiece of the last-named book, pen-and-ink and wash; bound up in six review copies only, and then recalled. Reproduced in "Early Work." (Property of M. Jean Ruelle.)

137. TITLE-PAGE, an architectonic design. First published as the title of "Early Work" (John Lane, 1899). (Property of John Lane, Esq.)

138. ORNAMENTAL TITLE-PAGE FOR "THE PARADE." Messrs
H. Henry & Co., Ltd., 1896. Reproduced in
"Later Work."

139. TAIL-PIECE to Catalogue of Lord Carnarvon's Library,
1896.

140. SAPPHO, by H. T. Wharton. (John Lane, 1896.)
Design for cover in gold on blue. Reproduced in
"Early Work." (Property of John Lane, Esq.)

141. PIERROT'S LIBRARY. (John Lane, 1896.) Design for
title-page of, two designs for end papers, printed in olive
green; design for front cover and vignette for reserve
cover, printed in gold on red cloth. Reproduced in
"Early Work." (Property of John Lane, Esq.)

142. LOVE ENSHRINED IN A HEART IN THE SHAPE OF A MIRROR,
pen-and-ink. First published in "Aubrey Beardsley"
by Arthur Symons. (Sign of the Unicorn, 1898.)
(Property of André Raffalovich, Esq.)

143. THE LYSISTRATA OF ARISTOPHANES. (Leonard Smithers,
privately printed, 1896.) Eight pen-and-ink designs
to illustrate—

 I. Lysistrata.
 II. The Toilet of Lampito.
 III. Lysistrata haranguing the Athenian Women.
 IV. Lysistrata defending the Acropolis.
 V. Two Athenian Women in Distress.
 VI. Cinesias soliciting Myrrhina.
 VII. The Examination of the Herald.
 VIII. The Lacedemonian Ambassadors.

 An expurgated version of No. 3 was published in
 "Second Book," and was repeated together with

expurgated versions or fragments from the remainder of the set in " Later Work."

144. THE RAPE OF THE LOCK, by Alexander Pope. An heroicomical poem in five cantos, "embroidered with nine drawings by Aubrey Beardsley," 4to. Leonard Smithers, 1896. Now published by John Lane. (Property of Messrs Keppel, New York.)

 I. The Dream.

 II. The Billet-Doux (vignette). Reproduced in *St Paul's*, April 2, 1898. (Property of Mrs Edmund Davis.)

 III. The Toilet.

 IV. The Baron's Prayer.

 V. The Barge.

 VI. The Rape of the Lock. (The property of Messrs Keppel, New York.)

 VII. The Cave of Spleen.

 VIII. The Battle of the Beaux and the Belles. Reproduced in the *Idler*, March 1897.

 IX. The New Star (cul-de-lampe).

 Cover design for the original edition.

 Cover design for the Bijou edition. (John Lane.) Reproduced in " Later Work."

145. DESIGN FOR WRAPPER OF CATALOGUE OF RARE BOOKS, No. 7. (Leonard Smithers, 1896.) A lady seated on a striped settee reading ; a parrot on stand on the right. Black on leaden-grey paper. Reproduced in " Second Book," 1896, and " Later Work."

146. THE PROSPECTUS OF THE SAVOY. DESIGN FOR.

 I. A burlesque Cupid on a stage with footlights, one hand holding a copy of the book, whence it

appears that the original intention was to produce the first number in December 1895. Reproduced in "Later Work." Latter part of 1895. (Property of John Lane, Esq.)

II. A suppressed variant of the above, same motif reversed, only with John Bull substituted for the Cupid. Reproduced in "Later Work."

III. Initial letter A in the above Prospectus. Reproduced in "Later Work."

IV. Publisher's Trade-mark for Leonard Smithers. First published in "Savoy" Prospectus. The same, name omitted, appears in "Later Work" with the title of "Siegfried," 1895.

THE SAVOY, No. 1, January 1896. (Leonard Smithers.)

V. Cover design, in two states. The original was suppressed because it depicted too realistically the contempt of the child in the foreground for the "Yellow Book," with which the artist had recently ceased to be connected. The revised version was republished in "Fifty Drawings," and again in "Later Work." (Property of Mrs George Bealby Wright.)

VI. Title-page. Repeated as title-page in No. 2, and republished in "Later Work."

VII. Drawing to face Contents. Caricature of John Bull. Republished in "Later Work."

VIII. The Three Musicians. Illustration of the artist's poem, same title. Republished in "Fifty Drawings" and "Later Work."

IX. Another drawing to illustrate the above, but with-

held. It appeared for the first time in " A Book of Fifty Drawings," 1897. Republished in " Later Work " and "Under the Hill."

x. Tailpiece to the above. Republished in " Later Work " and " Under the Hill."

xi. The Bathers (on Dieppe Beach). Republished in " Fifty Drawings " and " Later Work."

xii. The Moska. This subject was inspired by the children's dance at the Casino, Dieppe. Republished in the *Idler* Magazine, March 1897, and again in " Later Work." (Property of Mrs Edmund Davis.)

xiii. The Abbé. This and the two designs which follow appeared as illustrations to " Under the Hill," a romantic novel, by Aubrey Beardsley. Republished in " Later Work." All the illustrations of " Under the Hill " reissued with text in a volume bearing same title. John Lane, 1904.

xiv. The Toilet of Helen. Republished in " Fifty Drawings " and " Later Work."

xv. The Fruit Bearers. Republished in " Later Work."

xvi. A large Christmas Card, in black-and-white. Madonna, with fur-edged, richly-flowered mantle. Issued together with, but not bound in, the book. Republished in " Fifty Drawings " and " Later Work."

THE SAVOY. No. 2. April 1896.

xvii. Cover Design. Republished in " Later Work."

XVIII. A Foot-note. (Fancy portrait of the artist.) Republished, with omissions, in " Later Work." Also adapted in gold on scarlet for cloth cover of " Second Book."

XIX. The Ecstasy of Saint Rose of Lima. Illustration of " Under the Hill." Republished in " Fifty Drawings " and " Later Work."

XX. The Third Tableau of " Das Rheingold." Republished in " Fifty Drawings " and " Later Work."

Scene reproduced from " The Rape of the Lock."

THE SAVOY. No. 3. July 1896.

XXI. Cover Design. Republished in " Later Work."

XXII. Title-page. Puck on Pegasus. Repeated for the title of all the succeeding numbers. Republished in " Later Work." Also, reduced, as design for title-page of " Fifty Drawings," and in gold on scarlet for the under side of cloth cover of same.

XXIII. The Coiffing. This and the following design accompanied Aubrey Beardsley's "Ballad of a Barber." The Coiffing was republished in the *Idler* Magazine, March 1897, and in " Fifty Drawings " and " Later Work." (Property of Messrs Obach & Co.)

XXIV. A Cul-de-Lampe. Cupid carrying a gibbet. Republished in " Later Work."

THE SAVOY. No. 4. August 1896.

XXV. Cover Design. Republished in " Later Work."

THE SAVOY. No. 5. September 1896.

 XXVI. Cover Design. (Signed, for a practical joke, Giulio Floriani.) Republished in "Fifty Drawings" and "Later Work."

 XXVII. The Woman in White. A sketch in white on brown paper. Republished in "Fifty Drawings" and "Later Work."

THE SAVOY. No. 6. October 1896.

 XXVIII. Cover Design ; the Fourth Tableau of "Das Rheingold." Republished in "Fifty Drawings" and "Later Work."

 XXIX. The Death of Pierrot. A pen-and-ink sketch. Reproduced in "Later Work." (Property of Messrs Obach & Co.)

THE SAVOY. No. 7. November 1896.

 XXX. Cover Design. Republished in "Later Work."

 XXXI. Ave atque Vale ; Catullus, Carmen C.I. Republished in "Fifty Drawings" and "Later Work."

 XXXII. Tristan und Isolde. Republished in "Later Work."

THE SAVOY. No. 8 (the last issued). December 1896.

 XXXIII. Cover Design. Republished in "Later Work." The same adapted, with the addition of heavy black bands, and is printed in green and scarlet, for small poster to advertise the completed work.

 XXXIV. A Répétition of "Tristan und Isolde." Republished in "Later Work."

published in " Early Work." (Property of
Frederick H. Evans, Esq.)

147. A SEATED FIGURE. Unpublished design for the
Savoy, occurring as a grotesque in " Bon Mots."
(Property of G. D. Hobson, Esq.)

148. VERSES, BY ERNEST DOWSON (Leonard Smithers,
1896), cover design for. Reproduced in " Later
Work." (Property of John Lane, Esq.)

149. THE PIERROT OF THE MINUTE. A Dramatic Phantasy
in one act. By Ernest Dowson. Leonard Smithers,
1897. (Property of John Lane, Esq.) Four designs
to illustrate :—
 I. Frontispiece.
 II. Headpiece.
 III. Initial letter P.
 IV. Cul-de-Lampe.
Reproduced in " Second Book " and " Later Work."
Cover design for the same.

150. APOLLO PURSUES DAPHNE. (Property of Herbert J.
Pollit, Esq.)

151. THE SOUVENIRS OF LEONARD, Cover design for. Printed
in gold on purple. Reproduced in " Later Work."
1897.

152. THE LIFE AND TIMES OF MADAME DU BARRY, by
Douglas. Leonard Smithers, 1897. Cover design
for. Reproduced in " Later Work." 1897.

153. FRONTISPIECE TO A BOOK OF BARGAINS, by Vincent
O'Sullivan. Leonard Smithers, 1897. Repro-
duced in the *Idler*, March 1897.

154. COVER DESIGN FOR A BOOK OF FIFTY DRAWINGS, BY AUBREY BEARDSLEY. Leonard Smithers, 1897. Reproduced in gold on scarlet cloth. Republished on a reduced scale, in black-and-white, in " Later Work."

155. SILHOUETTE OF THE ARTIST. First published as a tail-piece at the end of " Fifty Drawings." Also in *Idler* Magazine, March 1897, and in " Later Work."

156. BOOK-PLATE OF THE ARTIST. First published in "Fifty Drawings," 1897, also in " Later Work."

157. ALI BABA. COVER DESIGN FOR THE FORTY THIEVES.
 I. First published in " Second Book," again in " Later Work," 1901. (Property of Messrs Robson & Co.)

 II. ALI BABA IN THE WOOD. First published in " Fifty Drawings," 1897. Also in *Idler*, May 1898, and again in " Later Work."

158. ATALANTA IN CALYDON. First published in " Fifty Drawings," 1897 ; also in the *Idler* Magazine, March 1897, and again in " Later Work." (This drawing was exhibited at the Carfax Exhibition, October 1904, under the title of " Diana," 77.)

159. MESSALINA RETURNING FROM THE BATH. Pen-and-ink and water colours. First published in " Second Book," again in " Later Work." This drawing, together with the other one of Messalina, drawn in 1895 (see *supra*), two of Bathyllus, and one representing Juvenal scourging a woman (this last, slightly altered, reproduced in " Later Work "), belongs to a series of illustrations to the *Sixth Satire* of Juvenal. Leonard Smithers, privately printed, 1897.

160. THE HOUSES OF SIN, by Vincent O'Sullivan. Leonard Smithers, 1897. Cover design for. Reproduced in "Second Book," again in "Later Work."

161. LA DAME AUX CAMÉLIAS. Sketch in water colour to right. On the fly-leaf of a copy of the book given to the artist by M. Alexandre Dumas, fils. First published in "Second Book," again in "Later Work." 1897.

162. BOOK-PLATE FOR MISS OLIVE CUSTANCE (Lady Alfred Douglas). Reproduced in photogravure in "Early Work."

163. ARBUSCULA. Drawing in line and wash, for the *édition de luxe* of Vuillier's "History of Dancing." William Heinemann, 1897. Reproduced in photogravure; also an early impression of the same printed in a green tint. (Property of John Lane, Esq.)

164. MADEMOISELLE DE MAUPIN, by Théophile Gautier. Leonard Smithers, 1898. Designs to illustrate :—

 I. Mademoiselle de Maupin, frontispiece, water colour. Reproduced in facsimile by Messrs Boussod, Valadon & Co., for limited edition, and, like the rest, in photogravure for ordinary edition. Reproduced as frontispiece to "Later Work."

 II. D'Albert (small design).

 III. D'Albert in search of Ideals. (Property of Mrs George Bealby Wright.)

 IV. The Lady at the Dressing Table. (Property of Walter Pollett, Esq.)

 V. The Lady with the Rose.

 VI. The Lady with the Monkey. All the above reproduced in photogravure in "Later Work."

165. BEN JONSON HIS VOLPONE: OR THE FOXE. 4to.
Leonard Smithers, 1898.

 I. Design in gold on blue for the cloth cover. Same
 in black-and-white for opening page. Frontis-
 piece, design in pen-and-ink.

 II. Vignette to the Argument. Initial letter V, with
 column and tasselled attachments to the capital.
 This and the remaining designs were executed
 in pen and crayon.

 III. Vignette to Act I. Initial letter V, with an
 elephant, having a basket of fruits on his back.
 (Property of Herbert J. Pollit, Esq.)

 IV. Vignette to Act II. Initial letter S, with a
 monster bird, having a pearl chain attached to
 its head. (Property of Herbert J. Pollit,
 Esq.)

 V. Vignette to Act III. Initial letter M, with seated
 Venus and Cupid under a canopy, between two
 fantastic gynæcomorphic columns. (Property
 of Herbert J. Pollit, Esq.)

 Vignette to Act IV. (The same as the design
 for Act II. repeated.)

 VI. Vignette to Act V. Initial letter V, with a horned
 terminal figure of a man or satyr. (Property
 of Herbert J. Pollit, Esq.)

All these Volpone designs were reproduced in " Later
Work." Drawn at the close of 1897 and early
part of 1898, they constitute the latest designs pro-
duced by Aubrey Beardsley before his death.

In his published List, Mr A. E. Gallatin mentions
several sketches and other drawings in private letters
which, for lack of detailed information, I have not in-

cluded in my List. Many of Aubrey Beardsley's drawings are constantly changing hands. In each case the name of the last known owner is given. Where no owner's name appears, no information has been obtainable. Some of the finest drawings, I am informed upon good authority, have now passed into the collection of Herr Wärdofer of Vienna.

I desire to acknowledge my indebtedness to the artist's mother and sister, to Mr G. R. Halkett, Mr H. C. Marillier, Mr H. A. Payne, and Mr Pickford Waller. To Mr Frederick H. Evans, who kindly placed his collection at my disposal, I am under special obligations.

AYMER VALLANCE

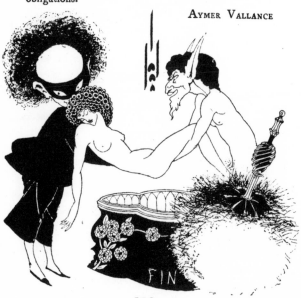